PHOTOGRAPHS NOT TAKEN

Editor: Will Steacy
Founding Editors: Taj Forer and Michael Itkoff
Design: Ursula Damm
Copyediting: Sally Robertson

© 2012 Daylight Community Arts Foundation

ISBN 978-0-9832316-1-5

Daylight Community Arts Foundation
Fax +1-775-908-5587
E-mail: info@daylightmagazine.org
Web: www.daylightmag.org

PHOTOGRAPHS NOT TAKEN

EDITED BY WILL STEACY | INTRODUCTION BY LYLE REXER

Daylight

TABLE OF CONTENTS

PREFACE

Photographs Not Taken is a collection of essays by photographers about moments that never became a picture. I have asked the photographers within these pages to abandon the tools needed to make a photograph and instead describe the experiences that did not pass through their camera lens. Here, the process of making a photograph has been reversed. Instead of looking out into the world through a camera lens, these essays look directly into the mind's eye to reveal where photographs come from in their barest and most primitive form—the original idea. These mental negatives depict the unedited world that could not exist in a single frame.

– Will Steacy

INTRODUCTION

The Art of Missing Information

by Lyle Rexer

Dear reader—I use this term instead of some others that might ordinarily be appropriate to a photo book: peruser, looker, browser, viewer—dear reader, you have in your hands a book of photographs that might have been "taken" by the Argentine fantasist Jorge Luis Borges, a book of photos without pictures. Or rather, pictures without photographs, since many of the images here are far more vivid than ones taken with a camera.

Is Will Steacy's brilliant collection, then, a species of contemporary art production grown familiar since Yves Klein presented an exhibition of empty space at the Iris Clert Gallery in 1958? Is it the latest chapter in the history of voids, negations, refusals, anti-art strategies, and marketing sleights of hand that, in their way, define contemporary art? We know about architects who don't build, artists who renounce the making of objects, filmmakers who tell no stories, musicians who explore only silence, and choreographers who revel in stasis. But photographers who renounce the image—these surely must be the last explorers of negative space. I am talking about classical photographers now, not those who have already given up on conventional camera relations in search of greater political relevance or as raids on the ineffable.

Truth to tell, the anecdotes collected here, personal as they are, reflect an aspect of the growing "crisis" of photography, a crisis that has to do with the self-consciousness of the genre and the broader ambivalence about the role of images in a media-saturated world. Yes, photography is a kind of atavism, a by-now instinctive response to the technologized, spectacular world, a mad cataloging that often resembles nothing so much as a vast collection of toenail cuttings. Yet these days every photograph taken by people who do it for a living arrives inside a set of quotation marks, a bracketed form of perception that says: "Don't trust me!" and "Should I really be showing you this?" and "Should you really be looking?" Above all, "Does it matter?"

There is more than a little agonizing in these reminiscences about the morally ambiguous character of photographic practice (although almost

no broader theorizing about the mechanisms of image distribution and control can vitiate even the staunchest political position). These second thoughts are usually framed in very personal terms, and I want to look briefly at a few of them, because they express exactly how and why photography is not like other arts, socially, politically, or psychologically.

First off, there are many kinds of missing pictures described here (just as there are many shades of darkness). There are: pictures that could not be taken, pictures that were prevented from being taken, pictures that were taken and failed, pictures that were almost taken but abandoned, pictures that might have been taken but were renounced, pictures that were missed and became memories before they could be taken, and of course pictures that were taken of one thing and were really about something entirely different that could not be shown directly. The artists have in some cases also rewritten Steacy's directive, supplying descriptions of pictures other people took, for better or for worse. See Todd Hido's memorable description of an oddly erotic photo his father once took of his mother that continues to haunt him.

The dilemma of the post-Magnum photojournalist usually falls into the category of the renounced picture, the result of having to choose between *to be* and *to shoot*, a choice that tragically defeated the photographer Kevin Carter. Ed Kashi encounters a terrible roadside accident in Pakistan, and is yanked out of his photographer's ambivalence by his traveling companion, a filmmaker who jumps into action as an instant EMT and drags Kashi along. To be or to shoot? No question here, but Kashi regrets the missing picture as if a piece of his memory had been cut out. A very different form of the same contradiction assails Elinor Carucci after she becomes a mother of twins. Not that Sally Mann has lacked for a lifetime of material involving her own children, even as they have become adults, but for Carucci, the fundamental challenge of motherhood is to be a mother. "The photographer declared war on the mother. And in those daily wars, the mother in me usually wins," she says.

Carucci's description is poignant, honest, and delicately written, just like her photographs, and it points up, for me, an undercurrent of frustration that runs beneath so many of these memories. The descriptions are so vividly rendered—each in its different way—because they confront the fundamental inadequacy of photographs in the face of experience. As Marcel Proust understood, memory is not exclusively or even predominantly

visual. It is synesthetic, a combination and even a confusion of the senses that no simple image can reach or encapsulate. A photograph can act as a spur to memory, it can yield treasures, like looking under your bed and finding the baseball card you were certain you lost. But an image stands mute before the inexpressible delicacy, horror, humor, and associative complexity of our experience. Many of the photographers offer descriptions or lists of pictures they wish they had taken, but they seem to recognize that what attracted them to those moments in the first place were often qualities or intuitions of reality that no picture could express. Doesn't language itself confront just such a limit?

That gnawing lack is precisely what drives photographers to seek more pictures and regret lost opportunities—and poets to write more poems. As Garry Winogrand knew, the desire to photograph the whole world, all of it, is not an attempt to recover or create memories. It is a need to affirm experience as expressible, if not comprehensible, and to create an aura of talismanic protection. Sometimes to gain that affirmation, you have to give up pursuing it. As she relates here, the photographer Joni Sternbach once failed to take a picture of a young boy, the son of a surfer in California. He wouldn't cooperate, and so she gave up on the picture. Instead, he gave her a Polaroid of himself, which she still has. Had she managed to take that picture, would it have been as meaningful, as expressive of the relationship between the two people?

Perhaps only in the presence of death (odd oxymoron: can death be present?), which cannot be imaged, do we truly face the trauma of letting go, of making do with only words, or even less, with ourselves and what we carry inside.

ESSAYS

DAVE ANDERSON

On Monday, November 3, 2008, I pulled into a poorly-lit cul-de-sac on the outskirts of Springfield, Missouri. It was dark and I was alone. I was also completely hell-bent on tracking down swing voters.

I had driven to Missouri from my home in Little Rock to volunteer for the Obama campaign during the final days of the 2008 election. Since it was clear that Obama had no chance of winning Arkansas and I wanted to spend a few days volunteering in a place that was still competitive, I had emailed my friend Ricki, who had an important job at Obama headquarters.

"Going to do some last minute volunteering," I wrote, "Am I more useful driving to MO or phonebanking from AR?"

Her simple reply: "Go to MO."

I packed a bag and began driving north toward Springfield, Missouri, a town I was in range of and that was in need of volunteers. I had my camera but did not expect to use it.

In the final weeks of a presidential campaign, and especially in the last few days, waves of volunteers stream into local campaign offices throughout every contested state in the nation. In many cases, these volunteers will be given photocopies of local maps and lists of targeted households in various neighborhoods and then sent out to convert the locals to the cause or to make sure those already poised to vote for the favored candidate actually do go cast their vote. This is called "canvassing." On Election Day, it's called "GOTV"—an acronym for "get out the vote."

I was a more enthusiastic canvasser than some of the other volunteers. I had worked in politics for many years but had been out of it for a while and wanted to give every scrap of energy to the cause during my paltry couple of days of volunteering. Normally, canvassing ends at sundown, but since I was hell-bent and all (and had nothing better to do in Springfield that night), I chose to stay out past dark. Nobody came with me.

The block was a bit spooky. On one side were small A-frame homes mostly inhabited by white, working-class families. Opposite the homes were some trees, bushes, and underbrush obscuring an active train track. A few streetlights illuminated parts of the neighborhood, but it still seemed pretty dark.

I consulted my sheet, got out of my car, walked to the first house, knocked on the door, and waited for someone to answer. Nobody came. So I left a flier and moved to the next home. It was pretty quiet on the street. At most of the houses, no one answered and, for the most part, I left only a trail of campaign literature about Obama and a set of directions on how and where each household could vote on Election Day.

After completing my canvassing of the neighborhood, I walked back toward my car. As I neared the vehicle, I began to notice the outline of a man standing off to one side who seemed to be fixated on something— me? Backlit, silent, and unmoving, he seemed frozen in place. Since it was dark, and the only thing illuminating his form was a porch light hanging high behind him, I could only make out his oversized, somewhat doughy proportions and long, curly hair. It wasn't quite a mullet, but it was close.

It made me a little nervous. He didn't seem overtly threatening, but I guessed that he was watching me and suspected that he was suspicious. And why shouldn't he have been? After all, it was after dark and I had arrived out of nowhere in a car with out-of-town plates, parked at no home in particular, and then gotten out and proceeded to knock on the doors of a seemingly random set of homes in his neighborhood.

Since his house had not been on my list I assumed he was either a Republican or a non-voter. He also seemed to be a relatively large man. The combination of his imposing size, mullet-like hair, presumed politics, and the general situation of my presence led me to the hurried conclusion that he might not be friendly. I also concluded that I would be better off not looking at or engaging him. But I also figured I had better not hurry or behave self-consciously. Either act really would look suspicious. So I focused all my energy on appearing normal. Just continuing on my merry way, really...

I continued walking toward my car and hoping nothing would happen. And for the next twenty feet nothing did. But I also sensed that he had not yet moved and I became increasingly anxious about the situation.

And then, just as I got to my car, a shout rang out:

"Oh FUCK!!!!!!!!!"

(That was him, not me. But I started thinking the same thing.)

Not sure whether his statement was driven by anxiety or aggression, I froze, then turned and replied:

"Is everything okay, sir?"

There was a pause, and then, "My cat died."

And then this large, scary, Harley-Davidson-looking dude with tattoos and a black leather jacket stepped into the light with a stiff, dead cat in his arms.

"She was such a good cat," he said forlornly. And then he began to cry.

I don't think Miss Manners has a section on how to conduct oneself in such a situation. And I don't think *Photo District News* has any advice to the working photographer on it either. And there's no guarantee I would have recalled any such advice at that moment anyway, given how bizarre the whole thing was. There were also so many things rushing through my head. Some of them included:

- Is this some kind of strange Republican practical joke?
- Should I go with it?
- How do I get out of here really quickly?
- Is he going to hit me with that thing?
- Can I take his picture first?

I guess the tears convinced me. It seemed like this big, tough-looking guy was genuinely upset about this cat. It was bizarre and, yes, to my twisted mind, darkly humorous. But it was also quite poignant. This was a person who had just lost a loved one and was really hurting. I wanted to help, but I also couldn't quite shake the sense that there could be something weird happening, and a sense of self-protection compelled me at first to avoid getting too drawn in. I also wondered if he would be angry with me if I tried to leave.

So I tried to be sympathetic. I asked how she had died. He didn't know. He told me she had just had kittens and that they were all OK. I asked if there was anything I could do. He said there wasn't.

And then he took a step closer to me, seemingly trying to draw a connection between us. Then, cradling the dead cat lovingly, the man lifted her toward me:

"You want to pet her?"

"Oh," I stammered. "Uh. No. That's okay."

Silence.

"But I'm so sorry about your cat," I added.

More silence.

"She looks like she was a sweet cat," I offered.

"Yeah," he said, "She was a nice cat."

I couldn't bring myself to take a picture of the man and his cat. The sight of a tough guy on a dark night tearfully cradling a dead cat won't soon leave my mind. But the moment seemed too raw. He was too sad. And I didn't have any good reason to give him as to why I might want to take a picture. I think when people are hurting you'd better have a very good reason to take their picture.

I wished him good luck, got in my car, and drove to the next neighborhood.

TIMOTHY ARCHIBALD

When I was fifteen, I was living with my parents in Schenectady, New York. On St. Patrick's Day, there was going to be a parade in the nearby town of Albany. I asked my dad if he would drive me there and hang out somewhere in the city as I walked around making photographs. I had been a big fan of Robert Frank's work *The Americans*, and as I looked at the overcast day ahead of us, I felt this parade would provide rich Robert Frank-esque material. Dad had the day off and agreed to take me.

The day was overcast but balmy and warm. I loved to shoot Tri X film and I knew the hazy daylight, shadow-less, would be perfect for such a thing. The town was essentially shut down for the day; the only things open were bars and restaurants, everything clearing out for this day of working-class celebration. My dad and I found a place to park and agreed to meet there three hours later.

As I left Dad and walked into the town, I had a sinking feeling. In the rush to get out and get organized, I had forgotten to bring film with me. I had talked Dad into taking me and encouraged him to bring a book to read while he waited for me, and I had totally blown it and forgotten the film. No stores were open. I had no money. I couldn't go back and tell him....I had to go through the motions of everything going as planned.

I entered the streets, me and my camera. I looked around and realized that I should just fake it...act as if I had film in the camera and see what came of it. The parade was kicking off...high school marching bands lined up in weary-looking uniforms. Veterans' groups gathered and prepared to get into the parade...some looking grim, some looking elated with the warm energy of early-afternoon alcohol consumption. I had previously been wrestling with the difficulties of photographing strangers. I was afraid to approach the people I was so curious about, or even those I was not curious about...there was always this fear or this shame about the camera. Today, it was different. Everyone was open, everyone was accessible. I shot amidst the audience as if I were invisible, often acknowledged with an approving smile. Was it me? Was it the holiday?

Though underage, I gained easy access to an Irish tavern. Everyone appeared to be intoxicated and, again, everyone was encouraging me to take their photograph. Here I was, sitting at a table in the window with a group of warm, smiling strangers, doing portraits of each of them. The

guy at the head of the table, wearing a paper hat, got sick and vomited. I panicked and looked around, but everyone just laughed. The sun streamed in behind him. The overcast day was gone but the late afternoon light was even better. The lady I was sitting next to, large body and long hair in a sweatshirt and a crooked smile, asked me to take a photograph of her in the back of the building, where her car was. I obliged.

This was the access and openness I'd always wanted my photography to have...but I never knew how to get it. This was my personal photo revelation, happening right then as the sun streamed through the window; these drunken revelers were showing me how do-able this all can be.

I left the bar and walked back to meet Dad. I was psyched and happy both with the small buzz of sneaking down warm beer at the tavern and with the feeling of bringing home the kind of pictures I'd previously only fantasized about making. Skipping a few blocks, thinking about the shots, I was brought back to earth when I remembered there was no film in the camera. For a second, it felt like I blew it. Oddly, that feeling went away quickly. As I walked back and found my way to my father, I realized that some door had been opened for me. I had found a way in with these people, they accepted me and my camera, and I wasn't afraid. This ability to enter someone's world is out there on the horizon. It can be mine to tap into. These pictures never taken led me to understand that there really is nothing to be afraid of.

ROGER BALLEN

I often drive along a certain street in Johannesburg, South Africa. A few weeks ago, I spotted a man whom I have known for many years. He was walking along the side of the road with a stained burlap sack over his shoulder. I stopped to talk to him and he reciprocated by asking me whether I could take him to the place in town where the witch doctors practice. I turned my car around and headed to this place in a run-down area of Johannesburg.

The man directed me to a house constructed of corrugated iron. When I parked the car, he jumped out with his sack, which made hissing-snarling noises. As we left the car, the witch doctor greeted us and directed us to a room in the backyard that was full of cat skins on clotheslines. Displayed on the lines were the anatomical parts of a cat: tails, paws, backs, heads, and so on.

Once in the room, the "Cat Catcher" went to the scale, onto which he laid his sack. The witch doctor played with a few metal weights and stated in an authoritative voice that there were twenty-two kilograms of cat for which the man would be paid. The witch doctor reached into his pocket and took out three one-hundred-rand notes, which he gave my friend. The Cat Catcher seemed very pleased with his day's work and asked to be taken to the place where I found him.

THOMAS BANGSTED

Some summers ago, while visiting my hometown, I borrowed a car for the day to drive around the Danish countryside scouting for locations. Toward the end of the day, I found myself lost and made a turn onto a narrow gravel road. Coming over a hill, it became clear that the road dead-ended ahead of me at an old farmhouse concealed by dense vegetation.

While weighing the options of where to turn around, I caught sight of a giant balloon-shaped object near the end of the dirt road. As I approached, it turned out to be a bloated cow on its back with its feet shooting straight up into the air. It was lying there near the road, belly full of gas. A common case of bovine bloat, but I was not quite sure what to make of it. It is said that an inflated cow only has minutes to live before the expansion of the stomach lining crushes its lungs. The cow was dead and, by the looks of it, ready to explode. My only other company on the side of the road was a distressed calf chained to a metal stake in a small grazing area. The air was thick with neglect and the calf gave moaning cries. When I returned to the car, a languid-looking cat with a limp greeted me. Gazing indifferently, it passed me by with a lifeless rat hanging from the side of its jaws.

The house hidden away at the end of the road seemed eerie after the brief encounter with these four dark protagonists. The sight was like a picture postcard that had taken a wrong turn—a case in point of dread in near-perfect equilibrium with the banality of bright daylight and a lazy afternoon.

JULIANA BEASLEY

I can only hear the shrilling voice in my head, "Take the picture, just do it, just do it! Don't be afraid. And don't feel guilty!" The voice is a blasting horn that pierces the intermittent mumbled and inebriated conversation around me. The voice is so loud I can feel its vibrations upon my shoulders.

Here I am in a low-lit room, sitting on a once dark-orange carpet now turned brown through years of spilled beer, bitter cigarette butts, and rancid dog urine. I look to the ground. I am in a lotus position, like the child I once was sitting "Indian style" at a friend's birthday party. Looking down to the carpet...I notice several cockroaches scurrying around me. I am probably more at home than I should be, my Contax on my lap as I change rolls of VC-400.

No, I am not at a relative's house, but instead sitting center stage in a circle of frayed and worn La-Z-Boys. A bunch of grumbling older Irish men with roseate faces keel backwards, drinking cans of Cobra and Guinness beer, engaged in a silent exchange. They share mutual glances every so often while eyeballing an old television. It sits upon a pedestal, a broken black-and-white set. The reception is shot; skin tones are fluorescent pink. Occasionally, a cackling grumble spills over, "Oh, the fuggin' cunt!" and a look of half acknowledgement and laughter at the crassness of it all.

The broken windows are covered in a blue tarp and the cold winter gusts whip against them and into the living room. The proprietor of the house, Paddy, had thrown a chair out of the window in a belligerent drunken fit. It's all makeshift and make-do around here. Charlie, Paddy, and Deuce, the guy who lives in an adult residence down the boardwalk. He appears at Paddy's maligned boarding house to sit with the boys. He drinks for free. In his shirt pocket is a Xerox photo of a pet cocker spaniel that he talks about with loving nostalgia.

Everyone hates John Trainer, the itinerant thirty-something alcoholic. He arrives on the scene and picks up a gallon plastic bottle of generic vodka lying on the floor next to the stumps of Paddy's amputated toes. He guzzles it down, sits down on a milk crate. He's a mooch. The others tolerate his presence.

I hear a gurgle and look to my right. John is foaming at the mouth. His eyes are rolling back. Boom. Man down. He's fallen off the crate and presently

is on his back, twisting and bucking. His head is spilled into the kitchen, his torso in the living room. Drool covers his chin. I put my camera down, rush to his side. "Are you all right, John? I'm right here with you...you'll be O.K. Don't worry, John." The blokes remain careened back in their majesty, completely disassociated from the events unfolding. "Throw me a pillow," I say calmly. I put it under John's bobbing head. Then, "Call the cops!" I drill like a captain at the helm. I turn John's head to the side. He won't choke on his saliva this way. I make sure that his mouth remains agape so that he won't bite his tongue in two.

This is the shot! This is the action shot. This is the shot that explains in one photograph the level of self-destruction I have been witnessing for the last several weeks. This is the shot that will make my book complete. Again, the voice in my head, "Take the picture! Leave his side and pick up your camera!" I don't. I can't. The voice that has always had its way...goes away.

The police have arrived. John has become conscious and returned from the world of cerebral thunderstorms and incongruities. They strap him to what appears to be a hand truck and pull him through the door. I hold it open. They know John well. "You're going over to the Peninsula, John. It's the best we can do for you." I can hear the boredom and callousness in their voices as they roll him down the path and into the darkness of the boulevard.

NINA BERMAN

A camera can get you close without the burden of commitment. It's a nifty device that way, a magical passport into people's lives with no permanent strings attached. So it was quite a decision for me to stop photographing a girl who was a terrific subject, and let her become something more... something more like a daughter.

I met her in London in 1990. She called herself Cathy at the time. She was one of hundreds of kids living on the street in the city's West End. We met outside a shelter entrance. She was pounding the door and cursing the world. We liked each other immediately and she let me into her life. I took pictures of her begging for money, smoking crack in parking lots, sleeping in doorways, and warming herself over a cup of tea. She liked that I came from New York City and I appreciated her daring and that she showed up when she said she would. Before I left London, I gave her my phone number in New York City and then I flew home.

I tried to get my pictures published, but no one wanted them. And then, some months later, Cathy turned up at Kennedy Airport. I knew that her parents and their adult friends had abused her. The abuse was ritualistic and severe. But I didn't know how disturbed she was until she had a flash-back. She spoke in the voice of a child. Her body shook and her eyes rolled back. She thought I was a man trying to hurt her. It was horrifying. Then she came out of it and, in tears, fell asleep. She curled up like a fetus and held her hands between her legs. She whimpered "no, no" and trembled in her dreams. I photographed her this way. I didn't know what else to do. It made me feel removed and less helpless. And then I felt disgusted. I put my camera down and I stopped photographing her. At that point, she had ceased being a subject of study and became instead a person in my life.

Seventeen years later, Cathy is Kim and I am her next of kin, at least that's where my name goes when intake workers fill out her forms. She's led a colorful yet sorrowful existence here in the United States. She's lived in crack houses and in the tunnels; she's been in Bellevue and Kings County, and programs with pastoral names in Westchester and Long Island. She's HIV-positive and just got out of a six-month nightmare on Rikers Island. Through it all, I could have taken pictures, but I didn't, except one, several years ago in Times Square, on a night I was sure she would die and I wanted to have something recent to remember her by.

Photographing her in depravity, showing her scoring, suffering, sick, and high, making images that are so valued in a certain tradition of documentary photography, seemed all wrong to me. The only pictures I take of Kim now are of her smiling, often with my daughter, whom she calls her little sister, and they go in my family album. I am hopeful that, before she dies, I will photograph her for an author's page of a book that she will write on her life story and it will be a beautiful photograph made with love.

ELINOR CARUCCI

Having photographed my family since I was fifteen years old, I could always ask, talk, and argue with my subjects. The people I photographed were adults, and they were aware of most of the consequences of the exposure that such a personal body of work involves. They could make their own decision whether or not they wanted to be photographed, what photographs would not be shown, and to some extent how they would be photographed.

It all changed when I gave birth to twins, a boy, Eden, and a girl, Emmanuelle, on August 19, 2004. I was facing new challenges as a photographer, as a human being, and in almost every aspect of my life. Becoming a mother meant that many photographs were not being taken. Every moment, I had to choose between photographing and mothering, and when I did choose photography, every photograph became a second of guilt, a second I neglected them, a second I thought about light, composition, exposure and not about them. Even if it was just for 1/125th of a second, I wasn't available in that 1/125th of a second. But there was no other way to make those images of the children and of me mothering them. I couldn't clone myself.

The intense emotions were something I had never experienced in that volume, the love, the anger, the physical connection, so sensual, almost sexual in a way, and I had to photograph those moments. The kids were growing so fast, moments that will never come back happened every day in front of my eyes, escaping my camera. I had to preserve them somehow, a need I always had. I had to take pictures.

So the photographer declared war on the mother. And in those daily wars, the mother in me usually wins. She is not only much stronger than the photographer, she also has evolution on her side. And thus, many photographs are not being taken because I have to hold, hug, kiss, feed, wipe, lift up, listen, cook, tidy up, yell, discipline, dress, undress, protect, and comfort, comfort, comfort.

Some of those photographs are stored in my eyes. Emmanuelle screams in the middle of the night, throwing her arms up to me, tears all over her face. Eden kisses my lips and tells me he loves only me. Eden in time out, eyes full of anger, refuses to say that he is sorry. Eden waking up from anesthesia after his adenoidectomy, still with the oxygen mask on his face, terrified.

Emmanuelle naked holding tight to me in the bathtub. Eden bleeding in the emergency room. Emmanuelle with a fever of 104, with eyes that look at me like nothing I have ever seen before. The majority of photographs are not being taken. When I decide to set so many limits, I pay the price with images empty of all the emotions I want to put in them, and this makes me the photographer I am today—torn.

KELLI CONNELL

- West Texas storm rolling in, July, on way to Colorado.

- Christine smiling, face up, eyes closed, soaking up the sun.

- Thomas in red chair. Light from apartment window enveloping him. His blue eyes intense.

- Thomas, wild-gray sky behind him, standing outside of car. Close up, his eyes after crying. Gaze like last scene in *Orlando*.

- White sheet hovering, falling on bed.

- Sunnye with her dogs, in bed, watching TV at night.

- Jacinda in new house in new town.

- Plaza Donuts on Belmont Avenue at sunset, the tennis courts (what's left of them) on Todd Lane, the drawing room on the fourth floor.

- Peter, close-up, office window light, with glasses and without.

- Brad floating / standing next to pool after working out.

- Joe, in basement, piles of laundry, pounds of coins.

- Marni knitting in winter, Barkley, her dog, nearby.

- Darby in the snow.

- Icebergs.

- Denton twins.

- Softball girls.

- That hot girl drummer.

- Light moving along the bottom of the pool.

PAUL D'AMATO

From the outside, you can tell there used to be a bar here, like a lot of these hole-in-the-wall joints shoehorned into every other block in the hood. The large plate-glass windows are cracked or only have pieces of the former window left with fragments of words remaining like "The Alc____." The rest of the windows are painted black from the inside or boarded up so that it's impossible to see in and now the place looks abandoned. Only last December did I realize that there is actually a private bar/club here when Rocio took me over to introduce me to her cousin Teyo. I wanted to watch the Chavez fight and all of the other bars I checked out earlier wouldn't let me take my camera in. They were all packed and it seemed that the crowds were so combustible that one flash might've been the spark that set them off. At this point, El Club was my last chance because the fight was only being shown on pay-per-view.

To get in, you have to bang on the window on Wood Street, then walk around the corner to the door on 18th Place and wait for someone to open the door, check you out, and then decide if they're going to let you in. Rocio says she needs to see Teyo (apparently all her cousins hang here) and we walk in. To get to the bar we have to pass through a small function hall where there is a strangely somber birthday party for a little girl. The room is lit by a single fluorescent strip in the middle of the ceiling. Then we enter the bar on the right. Nothing on the outside prepares me for what I see. The place is jammed and just about everyone is dressed like a vaquero. A sea of cowboy hats forms an arc radiating out from a TV suspended from the ceiling at the end of the bar. Spanish spills from the set and all the hats soak it in like rain in the desert. The States seem like a distant memory, like crossing the border in Nogales. See you later U.S., hello Mexico, hello Third World.

The next day I got the low-down. It used to be a real bar until about a year ago when their license was revoked after three guys were killed on the premises in various skirmishes. All three were white, Gumby tells me with a twinkle in his eye, until I get the joke, and then he laughs. Now it's a "private" club and you only get in if you know someone. They seemed so worried my first time there that it really made me suspect the place is way outside the law. I love that you have to bang on the window and then go around the corner to be let in. Inside, it's all Spanish, which is why

Victor calls it a brazer bar. Everyone else calls it Alcatraz because of the "Alc____," the only cryptic piece of the bar's former name left on a shard of the main window.

TIM DAVIS

When you look at masterpieces, you see weather. Annunciations, depositions, expulsions, visitations, these feel unreadably legal. So many great paintings, so much greatness, seems just a tangle of body parts, ever more skillfully arranged. The Renaissance is people standing around. By the Baroque they're writhing around, like a movie reel switched from an art film to a thriller. When you stood in Santa Maria Novella, in front of the restored Ghirlandaios, you stared right past all the martyrdom and wailing and attending—cheat sheets for churchgoers who couldn't read and couldn't understand the Latin mass—and took in the background clouds. Odd clouds. Clouds that look like the balled-up packaging of a cheap cloud toy, discarded behind a dumpster. Maybe set on fire. But no matter how strange a cloud gets, it's still a cloud.

You are nowhere near a masterpiece now. You are on a golf course, just down a long graded drive and up a hill from a landscape of American services. A corner with four different fill-up stations, two of which now belong to the same company. Herringbone parking lots, like the one at Mister Steak, where you watched with a group of beatified dinnergoers as a U.F.O. descended. It was a white dot that got bigger and bigger in the evening sky, and as it did your sense of "this is it" ratcheted into your thyroids. This is it. Well "it" turned out to be a stray advertising banner fallen from the back of a small plane. The ad was for a competitor, Sizzler, and the long vinyl strip landed on a bank of Mister Steak's halide-ballast parking lights and dangled there, like the big dirty angel at the top of Caravaggio's St. Matthew.

You're not sure why you are on this golf course. You have no clubs and don't play anyway. Golf is the stupidest sport you can imagine: no exercise, too much equipment to carry, worse for the environment than a speedway. Not knowing why you're there is disturbing for only a few orienting blinks. You are a photographer, and have spent much of every day drifting into the unfamiliar. When you're waiting for a train, you find yourself waking up into the same station you didn't know you were asleep in. Suddenly everything warrants at least a hmmm....The camera is an amnesiac constantly, comically and tragically, looking at a new world, and its amnesia is contagious.

On the golf course, all you see is weather. The sky is dark, a darker tone than the very green fairways if this were printed in black and white. There

has been an afternoon storm and the sky looks bruised. *When the Sky Goes Dark in the Day* should be the title of some bestseller about the pagan pantomime of a group of rich executives who make love with stable boys and flee to Mexico to dream. In this story, the sky is uncooked beef, more corpse than cloud form, hanging there recently relieved of life. And below it, down at the bottom of the hill and over the 17th green, a crowd begins climbing toward you. They are a scrambling mass, as far from a Sunday foursome as you can figure, all following some fellow, a tour guide, a point person, a celebrity, who is charging up the fairway. They hike up awkwardly, smaller in stature and gravitationally drawn to his huge suit and elephantine stride. With every assured step of his you come a little more unmoored. Who is this? Why are they here? Is this a media event?

The Sizzler incident taught you that "The Media" is an amniotic membrane you can push through, on one side fed through a tube, on the other screaming for your own air. When you are walking in the city and the cameras come on, the correspondents deep-breathe, the boom men raise their arms like Attic bronzes, you feel so grateful to be on the secular side of the camera, with no one reporting from anywhere.

They get closer. They are people following someone up a hill on a dark summer day. As they trudge up the wet grass, breathing harder, their urgency slackens and, with it, the incandescence of their leader. He's just as willful, his gait unchanged, but his followers' lungs ache. Soon you see him better than they do. On one side of the membrane he's a large, light-skinned black man in a sharkskin suit and no hat and damp loafers. On the other, he's Charlie Mingus. Blue-black sky stretches away to the distant commerce strip and Charlie Mingus walks toward you, his face a set of sags with a cigarette stuck in it.

For all our succor and scorn, celebrity is nothing but the plain and the familiar. Your mother is no one special, you just recognize her in the crowd above the bassinette. In those Renaissance paintings, celebrity virgins with their entourages standing around. Charles Mingus is here, familiar from album covers and store displays, and all else is wilderness. As he reaches you, he takes a hard left and lies down on his back on the ladies' tee.

You don't like the word "then." When you read you scribble little null sets over all the thens, embarrassed at how simple the formulas are for describing time passing. But as the sun comes down below the slab of

sky, gilding all you can see, you realize you've been saving all your thens for now. Mingus laid out on the manicured grass, just now backlit with alloyed haloes, and the wet course glinting and the sky all wrong. Here's what they mean by "Figure/Ground." A picture, readymade, as easy as peristalsis. This is the corpse you're always fantasizing finding in the weeds when you're out shooting and the world doesn't show up, the abandoned Warhol in an alley, the K-Mart bursting into flames. Photographers dream in content.

The camera is a metal roll film reflex hanging from your neck with enough real weight to remind you you have a skeleton. You raise it to your eye. And are immediately punished for it. You can't find the f/stops. The meter's broken. The focus ring feels unaligned and makes a gritty noise when it twists: when you force it, you can get infinity in, but not the foreground. You press the shutter and it responds with the saddest sound any mechanical thing can make: silence. You let it drop. A broken camera is nothing but a cobblestone, mightier than a sword but only because it can strike from a distance.

Before you, a Maxfield Parrish has been rolled in on flats. Mingus is still on his back, smoking, and when he takes a drag, the tip of the cigarette is the exact orange of the sunset tinge. What a picture. Pulitzers, Guggenheims, Prix de Rome, NYFAs, N.E.A.s, Louis Comfort Tiffanys, Turners, Nobels, MacArthurs pile up before you, the picture is that good, a masterpiece maybe. All you've suffered for, that badly-weighted backpack of failure you keep trying to force into the overhead, the unfinanced expeditioning, the sense that art has become the hare-lipped cousin of the entertainment industry, the endless envy and disdain, all this appears banishable by one click of one shutter. And then the light goes.

KAYLYNN DEVENEY

I usually get to know people before I start photographing them. I explain myself, my process, and my perspective and then—if they agree—I start to photograph. In working on long projects, there are many photographs that I choose not to make, but I do not lament the "loss" of these photographs. For whatever reason, my intuition at the time is to not photograph, and I trust that.

But when I am with strangers, photographing in a manner more like street photography, I am shy about raising my camera. Sometimes I don't when I wish I had; other times I am too slow, delayed by a momentary hesitation about whether I should or shouldn't take the picture. Those are the photographs it stings to lose. They take up residence in my mind and hang around to remind me that they don't exist anywhere in the real world.

I had been living in Northern Ireland for several months working on a photographic piece that I hoped could offer some commentary on what average days in Belfast were like in the mid-1990s. I was less interested in bonfires than home fires, less interested in soldiers than tea dances and piano bars. I was walking up a major road in West Belfast on a damp, gray morning before much was going on in the streets. The seagulls were calling overhead and swirling and I felt alone and quiet. Then I saw a man walking toward me, his coat buttoned up against the elements. The scene seemed colorless, just steel sky, silver gulls, and iron-gray coat. Then, for just a second, the gulls flocked around and behind him like attendants and in that moment it seemed as if he reflected the soul of the industrial northern city, forged from metal and mist. In that same moment, I hesitated, and my camera hung still around my neck. We passed shoulders.

This memory is over ten years old now. Who knows how I have changed it over time, remembering some things correctly while other aspects inevitably shift or disappear? But it is an image that I think about more than any photograph that I have actually made.

DOUG DUBOIS

On most days, you could find Clifford Woods playing saxophone in front of the China Trade Center on Grant Street. On weekends, Clifford played near Macy's on Union Square or sometimes next to the cafes on Maiden Lane. One time, a hulking old man walked up to Clifford and quietly complimented him on his playing. Turns out it was Stan Getz and his words kept Clifford going for weeks. Clifford played gigs too: with the bassist Herbie Lewis and once in a while with the reclusive trumpeter Dupree Bolton— who played only a few blocks away in Chinatown—when he could be coaxed off the street to form a quartet.

I was kind of a groupie, hanging out for a couple of hours or days at a time, making photographs, recording his music on my portable Walkman, and mixing tape compilations for Clifford and his friends. I was also in graduate school, looking to make photographs to fill the walls for my critiques. And I did, but they were mostly dark, smoky, clichés of jazz clubs and street corners, shiny horns and drums. The thing about music is that it does quite well without any visuals, but looking at a musician without the music is something else altogether.

If Clifford had a run of bad luck and couldn't make his nut for several days in a row, he would have to hock his horn or find a place to stay or a bath or a meal. It didn't happen often, but one night, he asked to stay on my couch. Around midnight, Clifford said he had to go out for a while but would be right back. I asked to tag along.

I suspected Clifford was an addict, not because I had seen him take anything or look strung out or even high, but he nodded out now and again and, you know, he played jazz. So off we went on a bus to the Tenderloin. Clifford told me to wait on a street corner and disappeared into a building up the block. People looked at me funny, a few laughed, but no one took me seriously enough to bother. I had my little Leica tucked under my jacket, but thought it best to stay put. Clifford returned soon enough and we were back on the bus and in my apartment in less than an hour. That was it for my angelheaded hipster night.

Now safe at home, I began to photograph. I had never seen anyone shoot heroin, but I had seen plenty of photographs and felt I had maybe not the right, but the permission to make some of my own. And even worse,

I considered, quite earnestly, that the scene before me was my rite of passage into something real and authentic.

Now I'd like to say I had the courage to stop photographing before I took advantage of Clifford's trust, of his need for a place to sleep, of his want and vulnerability, but I didn't; and I'd like to say that I never showed these photographs to anyone, but I did; and I realize that I'm bending the rules by writing of a photograph taken. But I offer this story as a corollary to our assignment here in order to say that putting the camera down is just as hard as picking it up and that my path to an ethical and honest understanding of what photographing means, as opposed to what photographs mean, was and still is marked by occasional lapses of discretion and decency.

The photographs of Clifford remain in a box with many, many others that are unlikely to see the light of day. But my awkward friendship with the man, his kindness and tolerance for a naïve and clumsy photographer, is a miracle that is as precious and lasting as my twenty-year-old recording of Clifford playing "Nica's Dream," now safely digitized and in rotation on my ipod.

RIAN DUNDON

Drinking was not optional. Nor had it been for the three days previous, three days occupied mostly with the pursuit of decadence and indulgence. Now, as I vainly attempted to fill my empty stomach with something other than Chinese Merlot, I dreaded looking across the table at the array of police and government officials seated there. I dreaded this because my gaze would inevitably be met by the ear-to-ear grin of that tax collector with his damn glass of booze. But it was already too late. His puppy-dog eyes and whiny little grunt signaled that it was my turn to drink, my turn once again to salute the health (or imminent death by alcohol poisoning) of the men assembled around this banquet of seafoods, liquors, and cigarettes. I rose slowly from my chair and summoned what I could of a smile, watching first as he downed his entire glass of wine in one gulp and then turned his empty cup upside-down, taunting me to do the same.

Of course I obliged. I had no choice. I had learned previously that noncompliance was not an option, a mutiny that would only be met with the group's disapproval and unanimous demand that I immediately do my duty and drink. I was their hostage, imprisoned in a series of overlit restaurants excessively adorned with food sculptures, flat screen TVs, and unconsumed delicacies in what amounted to a never-ending drinking game. For it seemed that this tribe of fat cats survived solely on the nutrients afforded by booze and cigarettes, the only alcohol-exempt meal being breakfast.

In China, where your manhood is determined by the amount of alcohol you can consume, I had managed a fair amount of success when it came to social affairs. Even as I struggled with the language, I was able to excel at the drinking contests and unspoken challenges that having dinner with Chinese men involves. I was often praised for my ability to stomach *baijiu*, Chinese rice wine, and for the fact that I seldom drank to the point of vomiting. Hand in hand with the culture of drinking goes the act of sharing and smoking cigarettes as both an icebreaker and reinforcement of friendship.

Offering an expensive cigarette to a prospective business partner or new acquaintance is a necessary sign of respect and friendship; handing him a cheaper brand is a slap in the face. It is no wonder, then, with the amount of business happening in China, that the highest rates of cancer there

are lung and liver, and that nearly seventy percent of Chinese men are smokers. And so it was that, through the affliction of these two vices, I had been able to circumvent the constraints of language and parlay myself into the good favor of many a powerful man.

"You better smoke one now. It is polite." My friend Johnny was whispering in my ear the rules of etiquette as his friend offered me a cigarette for the millionth time. A retired boxer from Beijing, Johnny (his anglicized name) had also previously worked in the government in a vague position having something to do with land development. It was he who had invited us along with him to Fujian province and the rural prefecture where he had held sway. It was his first time back in a few years and we were greeted with warmth and generosity by his old friends and coworkers. We didn't mind that his motives in bringing along two foreigners had more to do with his status in a town that rarely saw visitors than his desire for our company. This was China and we were used to it. Being someone's token foreigner was often a ticket into worlds otherwise inaccessible, in this case the life of county-level government officials and the leisure afforded them by their expense accounts.

When I look back at the images I did manage to produce during that hazy weekend, I see what an opportunity it was and what a waste that I succumbed to the constraints of my liver and lungs and followed those most fickle of organs back home to safety. I had gone there to photograph, but in the end I skipped out early, backed away from the bar, and left without saying goodbye. After three days of non-stop indulgence, things were getting on my nerves. I was sick from the drink and being in a state of perpetual hangover, and frustrated by the way we were carted around like monkeys, never allowed to stray from the group for our host's fear of losing face. We were something for him to show off, a status often afforded foreigners in interior China when their host is in need of praise from those he does business with. Johnny, having returned for the first time to his former home and still holding property in the area, was certainly looking to solidify his relations with those in a position to help him.

The tension culminated the night before our departure when, after many hours of karaoke, I decided to go to sleep at the hotel. Surrounded by overweight middle-aged men and the teenage escort girls they had hired to pour drinks, I attempted to say goodbye and leave. Johnny and his friends stopped dancing and looked at me in utter disapproval, steadfastly

denying my departure. Next thing I knew, two government officials were pinning me to my seat while a third shoved a beer in my hand. "Play more!" they were chanting, relishing my obvious intoxication.

The next morning, we stumbled to lunch, nursing hangovers with milk and bread, only to be confronted with a feast more lavish than any of the others. Prawn, lobsters, intricately arranged artichokes and oysters served on fine china with golden chopsticks. The restaurant's owner arrived and gave every man an eight-dollar pack of cigarettes, toasting everyone at the table, one at a time. After a few drinks, Johnny excused himself to vomit in the restroom, came back ten minutes later, and continued drinking when the local police chief raised his glass. Once again there was no saying no, no chance of abstaining from this orgy of excess, and so we drank and smoked again, more fearful of the silence that not doing so would bring to the table than of the consequences to our bodies. In between toasts, I attempted to eat my fill of the plentitude laid before me—difficult, as the fast rate of drinking didn't leave much time to actually eat. After lunch, with a belly more full of booze than food, my partner and I decided it was time to go.

I usually try to hang out until the end. The best pictures are always found at the end of the night after hours of waiting, when people are unguarded and receptive. The longer I hang out, the easier it is to let go of my own hang-ups and apprehension and just trust that the pictures will come. So what happened in rural China with a bunch of drunken guys who wanted nothing more than to be my best friend? I turned my back when I should have stuck it out. I didn't give it the time it needed or deserved, and I walked away fully aware that it was too early to leave. Doing this kind of work is rarely fun and that's something I already knew.

We left that afternoon, literally sneaking our bags out of the hotel moments before announcing an immediate departure. They all looked shocked that we would want to leave and tried to convince us to stay, pleading with us and promising more good times to come. But it was too late; we had made our move and surely lost face for Johnny. After much discussion, we were eventually allowed to go, but the tax collector insisted on escorting us to the nearest train station in his hired American luxury sedan. As we raced through the impoverished countryside of Fujian in a brand new Buick, he turned around smiling and said, "Your train doesn't leave until nine o'clock so my friends in the city and I have arranged for one last dinner before you go."

AMY ELKINS

We had been talking here and there. Once a week. Fourteen and a half minutes before hurried goodbyes were exchanged with uncertainty. It was our allotted time to share what we were experiencing. My new chapter in New York. His, in a federal prison, three thousand miles away. My father's stories were endless. His seventy bunkmates. Spanish ricocheting off of the concrete walls until it became static, white noise, a flock of birds. The mess hall. The books that had their covers torn off. The Hawaiian friend he made who sang like an angel. The night he woke to flashlights banging along the metal bunks, looking for inmates with blood on their clothes. The teams that were formed. The chess matches and basketball games. *Prison Break* on the television in the rec room. The pauses in his voice.

We had shared just under fifteen minutes a week for months from across the country. I mostly listened, the imagery leaping to mind, as his words came through the line. These were the things I wanted to make photographs of. By the time I actually had my one and only visit with him while he was in prison, my imagination had grown wild and I was so emotionally charged that I had to place my hands together in order to keep them from shaking, and to hide the amount of cold sweat pooling in them. There were metal detectors, x-ray machines, electronic drug tests, and questionnaires before my brother and I were led into locked waiting rooms, before we were led into a barbed wire walkway, before we were led to the visitors' area. No cameras, cell phones, keys, wallets, jewelry, hats, purses, food, or gifts were allowed. Just myself, my brother, my father, and a small square yard of short brown grass containing picnic tables, a walkway, and vending machines, wrapped in barbed wire fences, two rows deep. My father, looking aged by stress, wore a tan uniform that seemed to fall all around him like robes. His hair had grown somewhat wild and was whiter than I remembered it. His eyes were youthful and tired.

The photograph was in my head. The moment of panic, of not knowing what to talk about or how to catch up in reality, while families reeled all around us with children and their mothers or grandparents. The vending machine coffees and board games. I longed for this moment to stay preserved, as if it would become more real if I could hold it captive on film. Or that my story would be more intriguing if I could prove what it looked like. The photograph not taken, a portrait of what we had become, the fear that my family had failed me, the confrontation of unconditional love, a

portrait of uncertainty. Instead, I sat with my hands tucked against the worn-out wood of the picnic tables, watching and listening to the sounds of what we were able to be for a moment.

JIM GOLDBERG

Before I even took pictures I knew that I wanted to have them as hard copy memories. Once I was walking by my sister's room (she was just back from college) and the door was open and I peered in and saw her naked, changing the sheets on her bed...I wasn't snooping but she looked up from her chore and saw me looking. To this day, I wish I had a picture of my mind's eye to prove that her brother wasn't a pervert. I wish I had taken a picture of my end-of-high-school girlfriend M.S., because she was really cute and rich and was from Montreal, but I didn't have a camera then or know how to take photos. Now she is on Facebook, but won't show her face. I wish I'd taken a picture of the unidentified object flying toward me from the sky as I was driving on the Wilbur Cross Parkway. It came right through my windshield and engulfed my shoulder in pain.

I really wish I had taken a picture of me with my first love R.H. when we were in bed together in an old abandoned hotel in the Catskills. I was so happy—I knew what love was then. If I had that photo, I could use it as a gauge of how to recognize what love looks like. I wish I hadn't seen or taken photos of two kids from Raised by Wolves having sex and hitting each other in a drunken, stupid stupor.

My wife's labor was long and painful. The without-drugs, natural approach soon gave way to morphine and an epidural. Immediately when that long-ass needle went into her spine is when I reached for a camera to shield myself from fear. Thirty-six hours later, when Ruby's head crowned, there was no way in hell I would use a camera and miss those incredible moments.

Years ago when it became obvious that my wife and my problems were not going to go away, we took a trip to Italy with the faint hope that our vacation would heal our wounds. I remember us eating a delicious gnocchi with pesto lunch and having a huge fight right in front of our daughter. S.M. was crying and I was crying and it was so sad and we were both so upset that I didn't know what to do, so I picked up my camera and took photos of tears flowing down S.M.'s eyes and Ruby hanging off of her, sucking her thumb and wanting to comfort her crying mom. I have never shown this image, the saddest picture I have ever made.

A few years later, while designing a book about my life (called *Coming and Going*), I realized that there were literally hundreds of moments in my

family's lives which I could have documented but didn't ...mostly because I knew then that that proof would be too intimate for anyone else to see. So I created a fiction instead.

There are many images which I miss on purpose. I've done too many of them before and photographing them again doesn't change the world, or me. However, to be honest, there is a pang of regret when a moment is missed on camera...but usually now, there is an acceptance, that not everything should be imaged, or that actually getting the picture is not any better than not getting it at all, or maybe I am basically lazy and don't feel like getting my camera out and working. And usually the feeling of loss is lost into a memory and all is A-OK.

EMMET GOWIN

Recently, on finishing an interview with a writer, I was asked if she could see my darkroom. "Of course," I said, "but wouldn't you rather see my books? They might tell you more about me." The whole interview had been accomplished within arm's reach of some of my favorite books and I began to touch the spine of some of the volumes that had given me such hope, in some cases changing my life.

I went along in this way for several minutes reciting the values and beauties of various dear friends among my books: *Physics and Beyond, The Life of William Blake, The Nature of Nature, William Carlos Williams: The Selected Poems*, etc. Then I pulled out a wonderful little volume on the connection between human values and science. Her expression completely changed to a look I have rarely seen. Confused, I insisted. For almost fifteen years, I had asked photography students to read this amazing little book and I had often learned later of their delight, albeit delayed, and I myself continued to be informed and touched by its insight. The stark look persisted and I further pledged my sincere affection for this book in particular, although I was stunned by the dark feeling that had begun to fill the room. Finally, she stopped me. "I know," she said, "It's my father."

Her face, perhaps more than any explanation or story, told of a wondrous and probably difficult connection. Dumbstruck and speechless for a moment, I searched for the words that would bring this silent mental cinema of her experience back into the present. "Your father," I said, "also wrote a wonderful book about William Blake." "I know," she sighed, "another thing about him that I will never understand."

Since that day, the writer and I have become good friends. When I asked for her consent to my telling the story of this remarkable exchange, she said, "Of course, there's no problem." Only later, when I actually tried to retell this story to an audience, did I come to realize how much difficulty I was having in articulating this moment. The event, in all its perfection, was easy to remember, but still I struggled. The words "I know, it's my father" were especially difficult for me, and I found myself almost frozen by an unexpected force of emotion.

I am sure this experience touched me in particular because I have made almost no photographs of my own biological family. In retrospect, in spite of the deep love I felt for my own parents and the profound respect I felt

for the strength of their convictions, I can see now that their strict and deeply held religious beliefs made a difficult if not impossible subject for me. Needless to say, beliefs do not photograph very well, but, to be sure, there was more to this difficulty than a matter of representation. Families, our experience tells us, are capable of both the closest bonds and the deepest chasms.

They say that the Eskimos have over two hundred words for snow. The particularity of snow's variety must be an intimate reality to those whose daily lives swirl with the need for a certain understanding. We, on the other hand, need more words for forgiveness. Reconciliation, too, should come more easily and naturally to us than it does. Something of this need came to me the other day as I watched snow clusters form in the sky, clusters the size of falling leaves. Snowfall is like forgiveness.

GREGORY HALPERN

I recently stood at an intersection in New York and, for a long time, I watched people walk by, hoping to make portraits. One man didn't want his portrait taken. When people say no, it often gets me thinking. This man was about fifty years old and a bit hunched over. He looked a little spooked. His eyes were small and set inside deep eye sockets. His body looked as though it were not really his, as though it were something he was just wearing, as if he were in there, peering out, hiding from the world. It's a feeling I have had before, but I never knew it until I saw his face. I pictured the portrait I wished I could make, and I hoped it could show what I was thinking. I thought it might be a cruel picture to take. I wondered if the picture could avoid being simple or mean, whether its bleakness could be redeemed by some sensitivity.

I made eye contact with him, and then he quickly looked away. I forced myself to ask for a portrait, feeling predatory. "Excuse me? Sir? Could I take your picture?" He didn't look at me, but he flinched, and I know he heard me. He walked by and ignored the question. Of course I couldn't blame him. Would I let a photographer I didn't know take my portrait on the street? I know what photographers are capable of, and I vacillate over how aggressive I am comfortable being.

You can talk yourself out of taking portraits pretty quickly.

When I'm out taking photographs, I've noticed that positive momentum can build if people say yes to my request for a portrait. At the same time, it can happen that two or three people will say no, and then my flimsy sense of confidence in the enterprise of portraiture is altogether destroyed by a flood of doubts. Can you make a portrait that is not a caricature? Can you reveal vulnerability and frailty without taking advantage, without cheapening the picture and insulting your subject? Is it possible to make a portrait without reducing someone to a stereotyped or incomplete version of him- or herself? Can a portrait actually illustrate a person's fullness—his or her complexity, contradictions, and idiosyncrasies? And is that ultimately important? My answers to these questions are inconsistent and often change. What interests me in portraits is their complexity, their mystery and volatility. If they lose that, if they ever become all clear to me, I imagine I'll lose my interest in making them.

In truth, the act of going out to take photographs of strangers is something I dread. But I keep going back to it. Despite the anxiety of the process, I am fascinated by the delicacy of the exchange, the tenuousness of the relationship, and the unpredictability of the outcome. I am fascinated by how a portrait of a stranger can take on meaning for another stranger—how an anonymous viewer can look at that person (a person who in theory means nothing to him or her) and feel something. There is mystery and hope in that.

TIM HETHERINGTON

There are many reasons not to take a picture—especially if you find the act of making pictures difficult. I was not brought up with a camera, I had no early fascination for pictures, no romantic encounters with the darkroom—in fact I didn't become a photographer until much later on in life when I came to realize that photography—especially documentary photography—had many possibilities. One thing for sure was that it would make me confront any inherent shyness that I might feel. It did, but I still find making pictures difficult, especially negotiating and confronting "the other," the subject, and dealing with my own motivations and feelings about that process.

This personal debate about making pictures was particularly apparent during the years I lived and worked in West Africa. In 2003 I lived as one of the only outsiders with a rebel group that was attempting to overthrow then-President Charles Taylor. It was a surreal experience—cut off and living in the interior of the country, I accompanied a rag-tag army of heavily armed young men as they fought their way from the interior forest into the outskirts of the capital, Monrovia. Reaching the edges of the city was an exhilarating experience after weeks of living in a derelict front-line town with little food. At one point, the rebels took over the beer factory and, after liberating its supplies, turned part of the facility into a field hospital where people with gunshot wounds were treated with paracetamol. Outside the factory compound lay about five bodies of people who, from the look of things, had been executed. A number had their hands tied behind their backs and most had been shot in the head and, despite the graphic nature, I had no qualms about making some photographs of these people.

Not long after, government forces counterattacked to push the rebels out of the city. Everyone was exhausted from the lack of sleep and constant fighting, and the retreat quickly turned into a disorganized scramble to get out of the city. Soldiers commandeered looted vehicles, and I even remember one dragging a speedboat behind it in the stampede to escape. To make matters worse, government soldiers were closing in on the escape route and began firing from different directions on the convoy of vehicles. One rocket-propelled grenade took out a car behind ours, and at one point we abandoned our vehicles and took shelter in a nearby group of houses. I began seriously considering abandoning the

rebels and heading out on my own toward the coastline on foot, but luckily thought better of it and got back inside the car with the group I was with.

The road slowly wound its way away from the low-slung shacks of the suburbs and back into the lush green forest. Our close-knit convoy started to thin a little as some cars sped out ahead while others, laden with people and booty, took their time. The landscape slid by as I tried to come down and calm my mind from the earlier events—I was in a heightened state of tension, tired, hungry, and aware that I was totally out of control of events. Just as I started to feel the euphoria of being alive, our car slowed in the commotion of a traffic jam. A soft-topped truck up ahead that was carrying about 30 civilians had skidded as it went around a corner and turned over on itself. A number of people had been killed and wounded—probably having the same thoughts of relief that I had before calamity struck. Now they were dead and their squashed bodies were being carried out from the wreckage. Someone asked me if I was going to photograph this—but I was too far gone to be able to attempt any recording of the event. I couldn't think straight, let alone muster the energy needed to make a picture. I just watched from a distance as people mourned and carried away the dead. My brain was like a plate of scrambled eggs.

There isn't much more to add, but I always remember that day and the feeling of being so empty—physically, mentally, and spiritually—that it was impossible to make the photograph.

Years later, when I put together a book about those events in Liberia, I included a photograph of one of the people who had been killed outside of the beer factory. I thought it was an important picture but didn't dwell on what it might mean for the mother of that boy to come across it printed in a book. My thoughts about this resurfaced recently as I put together a new book about a group of American soldiers I spent a lot of time with in Afghanistan. They reminded me a lot of the young Liberian rebel fighters, and yet, when I came to selecting a picture of one of their dead in the battlefield, I hesitated and wondered if printing a graphic image was appropriate. It was an image I had made of a young man shot in the head after the American lines had been overrun—not dissimilar from the one in Liberia. My hesitation troubled me. Was I sensitive this time because the soldier wasn't a nameless African? Perhaps I had

changed and realized that there should be limits on what is released into the public? I certainly wouldn't have been in that questioning position if I'd never taken the photograph in the first place....but I did, and perhaps these things are worth thinking about and confronting after all.

TODD HIDO

There was a night when I was young, maybe ten years old, and my father, coming home drunk, had woken us all up.

That night, something I witnessed stayed with me: a glimpse of my mother through the wide open door of their bedroom. She was wearing her torn nightgown and a single sock, posing suggestively for my father as he took her picture.

Years later, I found my father's picture from that night in a stack of discarded snapshots in our junk drawer. It was like something out of a "Reader's Wives" section in a porno magazine—that's definitely where this kind of image comes from.

Somehow, we have moments forever saved in that drawer that you would think a family wouldn't want to remember. The photo remained there for years and years. Occasionally, it would migrate to the top of the drawer. I have since swiped it.

The photo corroborates what I remember of that night— that my mother wasn't happy about having her picture taken, and a reluctant complicity is there in her pose. It was a picture I did not take, but it has become a faded gateway into my work.

ROB HORNSTRA

Krasni Vostok, the Red East, is located in a remote corner of a remote corner of Russia. On a clear day, Elbrus, Europe's highest peak, is visible on the horizon. Immediately after the fall of the Soviet Union, the shoe factory closed its doors. The factory for electrical equipment, one village away, did not last long either. Suddenly the whole village was unemployed.

We drive past the main school and the almost closed second school, past muddy streets full of potholes. Old women from the cities have squatted in the houses in order to harvest crops in the autumn for their own use. In the village, many streets are deserted. Countless families have moved to large cities such as Sochi, just on the other side of the mountains, or cities like Moscow or Kislovodsk, where there is work. Attached to the houses that are still inhabited is a sizeable piece of land, where set amounts of corn, potatoes, herbs, vegetables, and fruit are grown. "It's actually never been very different," says Albert Khabatov, an unemployed builder who lives on one of these deserted streets. "Communism or not, we managed to sustain ourselves."

The school functions, even more than the town hall, as the village's social center. Abaza is taught here, the language of the main ethnic group that lives here. Even Lenin's slogans are still shiny and new. We promise to go back the next day for a comprehensive reportage. It is always nice in places like this, where sorrow seems to hang everywhere, to see signs of hope and development. In this case, it seems to be predominantly their ethnic identity that brings the inhabitants together and motivates everyone just a little bit more to hold the community and the village together, despite all these empty houses and despite the prevailing unemployment.

The next day, preparations for the harvest festival are in full swing. Neatly dressed, the children run, quivering with nerves, through the corridors. Homemade cakes and biscuits are carried in. But by the time the harvest festival begins, writer Arnold van Bruggen and I have already been stuck in the principal's office for several hours. The math teacher—the type with tinted glasses and sweat patches under his arms—was suspicious of our interest in the local school and started asking for specific work permits. Not that these are necessary, but as soon as someone in Russia has to take responsibility, they quickly become anxious. So the federal

security service (FSB), Karachay-Cherkessia's presidential administration, and the Ministry of Education become involved. We pack up our things.

In the end, we reach the compromise that we will come back when our accreditation and permits are in order. Then we will get back the rolls of film we handed in and can re-record the deleted video footage. The vice-principal wants to hunt wild pigs with us and we are invited to spend the night in the principal's house in the village.

A little later, we attend the harvest festival as guests of honor without a camera. A girl dressed as a cucumber and two boys dressed as a green cabbage and an onion, respectively, try to entertain us. Nervous girls sing songs in Abaza, the local language, agonizingly out of tune. Fantastic photo opportunities pass us by. What started as a story about the difficult resurrection of a village in remotistan has once again become a story about Russian paranoia and xenophobia.

EIRIK JOHNSON

In 1999-2000, I lived and worked in Cusco, Peru. During early June of that year, I made my way to the annual pilgrimage of Qoyllur Rit'i, or "Snow Star," in the southern Andes of Peru. I was accompanying a group of pilgrims from the town of Chinchero with whom I had become friends during my year living in Cusco. I did not know what to expect from the journey other than that the pilgrimage took place over five days and nights and was located at the cold and barren feet of glaciers. I intended to take many photographs.

The experience of the journey was so overwhelmingly remarkable that I returned for three more years to participate and photograph. One of the most surreal moments during the pilgrimage went un-photographed. During my first night at the pilgrimage site, I lay in my small tent in a boggy flat next to the Catholic sanctuary. I had spent much of the evening photographing and was trying to get some rest before dawn, a relatively impossible task. Tens of thousands of pilgrims come to Qoyllur Rit'i from tiny villages and towns to dance and sing nearly non-stop for days and nights. They don costumes of mythical figures with names like the "Wayri Chunchos" and the "Capac Collas" and dance along the mountainside to flute, accordion, fiddle, even brass band.

I sat in my tent and listened. I could hear the competing melodies of at least twenty troupes of musicians, some comprised simply of a guitar and cane flute, others including trumpet, tuba, snare drum, and accordion. There must have been at least one hundred groups of musicians playing and dancers singing old village tunes all at once. Then, over a muffled loud-speaker from atop the sanctuary, came the amplified voice of a young indigenous boy singing Catholic hymns. Lastly, I heard the sound of a group of "Ukukus," young men dressed as mythical half-man-half-bear creatures, as they whistled into tiny bottles dangling from their necks. They blew in cue with their step and I could feel the soft ground shake as they skipped through the boggy clearing. There I lay in my sleeping bag trying to decipher the massive cacophony of sound as it bounced from one side of the glacial valley to another. I thought of unzipping the tent and trying to photograph the aural experience. But what would've been the point?

Seven years almost to the day, I can still vividly hear that most strange mix of sound as it echoed in the mountains. No photograph exists.

CHRIS JORDAN

My most memorable non-photograph happened at a backyard barbecue about eight years ago. It was a clear, warm May evening and several families were gathered around our patio for a birthday cookout. One of the adults had just laid an array of sausages on the grill, and with a hissing sound a thick cloud of smoke rose into the air, drifting slowly across the patio and into a large apple tree. The sun lay low in the western sky, shining right through the middle of the tree from where I stood. As the cloud filled the tree, the shadows of all of the branches and leaves suddenly cast a spectacular three-dimensional sunburst pattern on the smoke, shooting a thousand rays of undulating light outward from the tree's center where the sun was shining.

I remember opening my mouth in amazement, but before anything came out, in the next instant my three-year-old son, who was wearing nothing but a pair of bright red swim trunks, ran under the apple tree and stopped with his back to me in the middle of the smoke cloud, stretching his arms out wide so the smoky rays streamed through his fingers as his body became part of the sunburst. For just a moment he stood basking in the center of the light like a tiny monk beholding The Answer.

My camera was on the picnic table about two steps from my right hand. I half-turned toward it, then stopped because I saw that the scene was only going to last another second—it was fading already—and now the smoke drifted on through the tree and the sunburst evaporated, and Emerson turned and ran back to his friends. That was it. I looked around. No one else had noticed it. The whole spectacle had lasted just a few seconds.

The image from that moment is one of my personal favorites; but for this one my eyes were the camera, and my memory is the print. It is a portrait of my son, all innocence and hope and wonderment; a private exhibition in a non-archival edition of one, that I enjoy returning to again and again.

NADAV KANDER

When I was a kid, I had a real thing for spy movies: *In Like Flint, The Spy Who Came in From the Cold,* even *The Pink Panther.*

I think it was this fascination with espionage that led me to dream of the ultimate tool in my secret detective kit: a camera concealed in my hat.

Out of the corner of my eye, I would spot moments perfectly composed which were over as quickly as they began. I wished so much to be able to capture them, but they were always so fleeting that the camera in my hat would be the only way.

At the time, I was wrapped up with the frustration of not achieving every picture. But now, with the wisdom of time, I know that I can thank these frustrations for their driving forces. In not achieving every picture I wished I had taken, I have made myself more alive for the photographs I've gone on to author.

Later in life, when my three children were born, I only photographed the beginning of the labor of my third child, and never the crowning (the birth moment) of any of them. I regret this only a little, but I know that I'm at peace with the decision. I wonder how valuable pictures of my children at the moment of their birth would be to me now, but sometimes you just get an instinct when to put the camera down and be fully present.

ED KASHI

I can remember the first time I felt that photography couldn't possibly capture many of the amazing moments I witness in my life. It was in Nicaragua in 1983 where, as a young photographer, I felt that the fullness of the world I was seeing could not be reduced to images. But there are also times where, in the midst of an incredible moment, I decide not to make pictures. Usually there are various ethical, personal, or tactical reasons for this decision. My impact on the situation will be negative and I don't believe the images will serve any purpose, or by photographing I might hurt my chances for access further down the road, or I am needed in that moment to be there as a human being, not an observer/documenter.

Recently, I was in Pakistan working on a project and encountered a most horrific scene on the road, and I decided to not make a picture, but instead try to help. Yet afterwards I was haunted by the image that was resting in my head, and as the days went on and the haunting images from that scene faded and morphed, I realized I wanted a clear document of what I had witnessed. It was as though by not photographing something, I hadn't really witnessed it. This served as another reminder of how my photographs form the bulwark of my own personal memories. I often say, "I photograph, therefore I am." I would make a slight adjustment, "What I photograph is what I remember."

What follows is my journal entry from that day in Pakistan.

9/20/09

Lahore....it feels great to be back at home. At least that's what Lahore feels like after being south, being off the internet grid for the past four days and because we're staying in a very nice hotel. I feel slightly guilty about it, but we're within our budget so fuck it! We're working like dogs without breaks.

This morning I started out shooting in a square in Bahawalpur, a supposed hotbed of militant activity, which is a sleepy, mellow place. There is a jet fighter mounted in the middle of the square and I was using the early morning light and colorful traffic passing by to try to make a sense of place image. It was fun and I had a good time interacting with the people. I must say I'm finding Pakistan to be very friendly and in fact more gentle

and humble than India. It's interesting how much my attitudes and perceptions of Pakistan, vis-à-vis India, have changed in a decade.

We then did an interview with the district police commissioner, based in Bahawalpur. He is a very nice gentleman whose son is going to NYU. Pakistan is full of guys like this. He admitted there are about 80,000 students in his district alone, with ten million people, who are going to militant madrassas. He said it's not a good thing, but the government needs money to rehabilitate and offer alternatives. It reminded me of how we screwed up after the Soviet/Afghan war by not rehabilitating all the jihadis we trained and equipped to fight that war, so now they've taken on a life of their own and hate us.

We then drove the very long eight hours back to Lahore. Something incredible happened about an hour outside of Lahore. We encountered a terrible road accident, in which a couple and their two-year-old son had just crashed into a truck. It was a graphic and horrible scene, almost like a setup in a horror movie. The man lay sprawled, with his legs akimbo, his guts spilled out of his side, his head smashed in and fully dead. His wife was lying in a pool of blood, screaming and holding onto her son, whose head was split open and barely alive. There was a small crowd that had gathered around them but nobody knew what to do. It's incredible but after five minutes nobody had called the police or an ambulance yet. Upon seeing what had happened, Mick (a filmmaker accompanying us) sprang into action, running to our vehicle, grabbing his emergency medical kit, putting purple latex gloves on and he started to administer help. The man was dead but we couldn't tell if the boy was alive. He enlisted John, the writer and I as his ham-fisted helpers, putting gauze on the little boy's head while his mother was beating her chest and crying out in horror and pain.

After a few minutes of this, Mick rushed the boy to a car whose driver had offered to drive them to the nearest hospital. I helped guide the mom to the car. She was covered in blood, her husband's guts and she was a bloody mess herself with gashes and bruises. Mick and Imran sped off with them and we hopped in our van and followed. About fifteen minutes later we found a government hospital. The boy had died in Mick's arms in the car while he administered CPR. Mick was amazing. He is a one of a kind human being.

By the time we arrived at the hospital, Mick was holding the woman's hand as the nurses gave her shots to sedate her. The boy lay dead in an

adjacent table, a slab of concrete, with the young man who drove them tenderly holding his hand over the boys' eyes and reciting silent Muslim prayers. I'll never forget this scene of Mick holding the mom's hands, who was in absolute shock at that point, and the boy's covered face.

Mick was a bloody mess and hyped up. He looked scared, drained and slightly deranged. Our lovely ride home had turned into a tragedy for him. We got his shirt off and he did a preliminary wash with our water bottles and then we sped off to get home. But not before he demanded a vial of blood of the boy. Since he had performed oral CPR on the bloody kid, he wanted to take a sample of the boy's blood to be tested for HIV. It seemed totally irrational, but given his state we were not going to deny him this assurance. We then drove another hour and a half, crying, talking and trying to get this incredible experience in perspective. We went directly to a new, private hospital and within an hour he had the results, negative! What a day. Mick is an amazing man.

MISTY KEASLER

After living in Transylvania the beginning of the summer of 2001, I spent the latter half of the three months traveling around the rest of Romania. I was spending a couple of weeks in a building created for factory workers that had been turned into a ghetto when the last communist dictator of the country had forcibly settled many gypsy families into rooms there that were designed for one person. Their living conditions were bad – there was no electricity or running water and some families as large as sixteen were living and sleeping in one 12'x12' room.

I was standing in the dark hallway—light only came in through tiny windows at either end of the hall—when a man came out of a doorway where I had been earlier, taking photographs of the room where his family lived. They had shown me pictures of one of their daughters they claimed had disappeared, but other residents told me the community suspected the impoverished alcoholic man had sold the girl. He was very drunk and was dragging his three- and five-year-old little girls behind him. He started yelling at me to take pictures, that he would show me how terrible life was for the people living in the building, how sad and tough things were for them. The girls were still and stiff, looking up at him with huge eyes. He proceeded to lift both girls by their shirts and slam them into the concrete wall in front of us. They hit the wall and slid down it, stunned. It took them a moment for the pain to register and they started crying in loud, pitiful sobs that made my heart ache.

I had been frozen for the whole scene, but I threw my camera in the bag, pulled my sunglasses on, and headed out the door as quickly as I could. The man followed me, pulling with him the girls, who were still crying. "You come back tomorrow!—I am going to cut their hearts out—I will, too!—then I will throw them in front of cars—I will sacrifice them to show you how tough life here is!" I was so enraged I wasn't sure I could control myself. I was afraid I might attack the sad excuse for a father with a hunting knife I had in the bottom of my bag if I dared stop and address him. Hot tears ran down my cheeks. The appointed community leader was at my heels. "Get him away from me," I managed. His wife swept up the girls and other men grabbed the man. "I am calling the police—that man shouldn't have those girls." The leader begged me not to—he was afraid the police would do a general sweep of all the children in the building and take them to an orphanage, especially since everyone was gypsy and open

racism is still common. He said it would destroy all the families there. He promised they would take care of the man and "do right" by those little girls. I promised to think about it.

I went for a run when I got back to the house where I was staying and cried more. I didn't call the police in the end. I am not sure I made the right decision. I am sure of the choice to not make an exposure of that horrific event—I never would have been able to reconcile the fact that violence, especially to children, had been created for me and that I had documented it.

LISA KERESZI

There are always the ones that got away. They got away for a few reasons, some because I was living my life, out and about without the camera, like when I drove past the disaffected teenage girls in camouflage waiting for the bus on a fall morning, some sitting, some standing. Or there are the situations where I stopped to stare too long before remembering to put the camera up to my face. I have found myself lately sometimes staring at wonder at something, experiencing it, then I come back down to reality and realize the camera is in my bag or in my hands. There have also been many times that I just wasn't paying attention clearly enough to compose the right picture. There are lots of those—they call them "seconds," I suppose.

But there are things I cared more deeply about, that I saw or experienced when I was young. These things, and the yearning to somehow recapture them, figure strongly into my mindset as a photographer. I did take photos as a child and a teenager, but not of the things I wish I had thought to photograph. Instead of photographing the old "haunted house" farmhouse across the street with bats living in the porch eaves, just a mere few feet from the five-lane road we lived on, I set up my Barbies in various scenes and photographed them, pre-Todd Haynes-style. I also was obsessed with the beach, and tried to make picture-postcardy images of my docksiders perched next to the dunes. I was busy photographing my fantasies, and not my actual life. I failed to have the foresight or need to photograph the fantastic nightclub I went to, Pulsations. It was completely mirrored, the size of a Walmart, and included a robot that came down from the ceiling in a flying saucer. It has long since been demolished, after a light fixture fell from the heavens and hit a woman.

Today, some of these things I saw earlier in life are no-brainers as subjects of pictures. There was the house of an ex-boyfriend, whose father was a compulsive hoarder of newspapers, stacked as high as me, so the house became maze-like. There were my dad's biker parties with Evel Knievel-style bike tricks on Route 352 at the bottom of our driveway. There was our basement, with my art studio and science lab set up next to his lair, cordoned off by a hanging Confederate flag. There was the Harley Rendez-vous in upstate New York that the family traveled to in my dad's "Harley van," a black Chevy Nomad with Harley-Davidson stickers. I saw a few things during the day that my mom probably did not want me to see, like

biker babes flashing their tits, and general debauchery. I was traumatized, though, not from what I did see, but because she put me and my sister to bed in the van at night while they went out to see my favorite, Joan Jett, in concert. I was devastated. But I digress.

There was also my Uncle Mark's transformation from a regular hockey-playing young man into a Jesus freak. At a holiday, I remember him walking in while we were watching a heavy metal video on MTV, complete with scantily-clad models in teddies. He threatened to throw a brick through the TV, and turned it off. He also deemed his previous interests (Dungeons and Dragons and various role-playing games, Mad Balls, Garbage Pail Kids stickers) equally unholy, and proceeded to remove them from the house. He lived with my grandparents, right next door, and I remember walking across the gravelly driveway to see a makeshift table set up outside the back door, piled high with all of said items, destined for the trash pile. That is something visual that has always stayed with me, something that I wish I had thought to document.

He also took us to Evangelical churches, where I was "called" personally by the preacher, pushed to raise my hand to be "Born Again." The access to the desperate, the defeated, the huddled masses with their broken jaws wired shut, their tattoos and frosted tips, and flailings about on the floor, speaking in tongues—that was childhood access I wouldn't try to achieve today (or want to, really). Uncle Mark committed suicide about ten years ago, so that has something to do with my fixation on his table. I am not much one for recreating or setting up scenes, so the table of goodies will have to continue to exist only in my memory.

ERIKA LARSEN

The photographs not taken are the photographs not given. In many ways this philosophy keeps things quite simple for me. When I take pictures I become as much a part of that moment in time as the person I am photographing. Their path will inevitably take on a new dynamic as does mine because of the exchange. Sometimes that change is fleeting or not noticeable until later, other times it is profound, and occasionally it is emotional enough that the photograph—my purpose for being there—ceases to matter. There is one such moment that stands above all others for me.

I was working on a story about a young girl named Julie who had taken her own life. She was seventeen. I spent the day with her family, listening and taking pictures. While I was there, the father agreed to take me into Julie's room and show me some of her belongings that were most meaningful to him. It was the first time he had entered the room since she died.

He first pulled out some posters she had made for school, a scrapbook, and some old pictures. Then, when I asked what made him feel the strongest connection with her, he went behind the door and took off a hanging crib ornament that his mother had made for Julie when she was born.

He sat on her bed and told me his mother had died the same year that his daughter was born. He began to cry.

Sitting there sobbing, he held the ornament of a bear in a hot air balloon.

He was surrounded by white—the walls, her bedspread, the window light. He became a small speck of matter engulfed in a mist of white.

I could see the image, but I could only hear his sobs and feel my own falling down my face.

I held my 4x5 at my chest, ready to shoot, but not able to. I put down the camera; the moment was his.

SHANE LAVALETTE

One afternoon, inside of a dusty shop, I noticed the winter light lay itself on an old man's hand as he traced the knots in a piece of pine. The way the man spoke to me about trees and about wood suggested I consider the sheer size of being alive.

I listened carefully and watched his breath curl off of his lips. I watched his fingertips find pleasure in the material. I watched as, for an instant, he paused.

He stood there in the cold air as if he had reached the very end of himself. Naturally, I felt my hand move toward my camera but did not look away from his downward gaze. In the time that the moment suspended before me passed, I wondered how a photograph could ever explain any of this: what it is to be alive, what it is to love, what it is to die.

And then what I saw in the scene was gone.

As I left the shop, I thought of all of the images that seem to answer such existential uncertainties with eloquence. Often times, I wish I had made a photograph of the old man standing there in that sawdust glow, but I am pleased, more than ever, that I can remember it as it was.

DEANA LAWSON

Dana arrived at the yellow house, moving slow. I saw her while washing the dishes, the top of her afro bobbing at the window. Shaking the dishwater off my hands, I walked over and opened the door.

My twin sister stood there contemplating how to walk up the steps. There were only three. She stood still, wobbly, knees bent, shaking, white plastic bag in hand.

This was the degeneration the doctors predicted: "She'll be in a wheelchair in a matter of months." It was a sight that awakened me, a turning point. While I continued to hold the door, my instincts told me to run and get my camera. I was witnessing Dana (myself?) at a crossroads. The drug use, the alcohol, the cigarettes, the coffee, the spiritual isolation, and the disease: all had played their parts, and they were catching her.

Maybe ten seconds passed, maybe thirty, and eventually my delayed reaction kicked in. I extended my hand and she grabbed on tight. I had to steady myself, and she raised her feet.

JOSHUA LUTZ

Driving south on 7th Avenue, I dropped Melissa off on the corner of Christopher Street. Somehow we thought the day was going to go on as usual. The demo of a wall in my studio was going to happen, the prints I needed to make would get done, and in a few hours we would talk about what we were going to do for dinner later on that night. As I rounded the corner of Varrick and Beach Streets, Howard Stern was the first to announce that he, too, was watching the smoke come out of the World Trade Center. Upstairs, my dad and I recalled the 1993 bombings that shut down the neighborhood for weeks in my senior year of high school. I grabbed my camera and, with a friend, walked to the base of the World Trade Center. It's not that I didn't want to take a photograph; I couldn't. I was no longer a part of my body. We watched the bodies fall, the buildings collapse, and the people run.

As photographers, we dream of these opportunities to photograph the unbelievable. To bear witness and capture historic events, moments in history that will be discussed for lifetimes. For me, the experience of events is altered really quite drastically when I photograph it.

I have used photography as a tool to separate myself from some pretty horrific experiences in my life. Being on one side of the lens and not the other, I was able to turn on and turn off my relationship to these experiences. I guess it's a coping mechanism that I picked up at a really early age. As much as it can help to separate myself from difficult situations, it can also keep me from truly experiencing events. For this reason, I generally don't take pictures when I go on vacation. It's not that I don't want to have a photograph of the moment; it's more that I would rather be living in the moment than worrying about capturing it. Looking back, I believe it is this idea that prevented me from taking any pictures on September 11th. The cloud of smoke engulfed lower Manhattan and my camera remained at my side the entire time. Thirty-six frames of unexposed film.

DAVID MAISEL

When I was perhaps four years old, and I found that bird, dead in the street in front of my house, I didn't photograph that. I saw it, and later I painted it from memory. Was I too young to have a camera then? In any case, the image was indelible. It somehow merged with the painting that I propped up against the house, a marker to indicate the spot where my father had dug up the ground and buried the bird, at my behest, underneath a blanket of ivy.

When, as a child of six, I visited my grandparents' house, and tugged open the heavy bottom drawer of the dresser in the childhood bedroom of my mother, and found a long coil of her auburn hair wrapped in tissue paper, I didn't photograph that. I can recall how the tissue paper was wrinkled, and a bit brittle with age, and slightly discolored. The mystery of the past was there in that coil—cut from my mother's body, before I was born from that same body. I couldn't articulate it at the time, but there was something so disquieting about it. I recall how the hair was surprisingly vibrant, with reddish glints running through it. But I didn't photograph that.

When, as an adolescent of fifteen, I sat at the window of my room on my birthday, and looked down on the magnificence of the magnolia blossoms dripping with rain in my backyard, and my gaze merged with the spongy whitish-purplish redolent flowers and the reflective droplets of water, and everything was still and I was inside the leaves and the water and the air, and a bolt of lightning zagged out of the darkening sky and lasered the yard white, I didn't photograph that.

When, as a young man of twenty-three, my friend became psychologically unmoored, unloosed, and attempted to blind himself in one eye, and basically succeeded, and I spent a crazed hour with him, trying to make sense of what he had done, trying to put the world back together, and attempting to reassure him that everything was all right, even though it was, of course, nothing like all right at all, I didn't photograph that. I saw it very clearly though, and recall it still—the blackened skin around one eye, the fierce determination in his other.

When, as a man of thirty-three, the light poured onto the ocean that stretched to infinity outside our window, and everything was new again, and everything was glittering and glinting and bright with possibility, I didn't photograph that. The world was new, because there was light in

it again. There was light because we had come to live, through an accident of fate, in a jewel-box of a house, perched above the ocean, and the ocean beckoned and the light arose out of the ocean and everything was possible, and I was unafraid of it being new, because it was beautiful and it was just outside my window and my life was mine and I knew not to even try to photograph that.

MARY ELLEN MARK

As a child in grammar school, I had a Brownie camera and would snap funny pictures of my friends in weird and silly poses. I did the same at summer camp. I would run to the local drugstore to have the film developed. I couldn't wait to see the results. Those tiny little square prints—how I loved them. I didn't start photographing seriously until I was in graduate school and in my early 20s.

I really regret that I wasn't a serious documentary photographer in junior high school and high school. Those were such visual years. I remember so well all the ups and downs, the exciting moments like going to the prom, or becoming a cheerleader and then a head cheerleader, my secret crushes, and my first kiss. (Believe it or not, I was madly in love with a boy named Smoothie. I thought he was so cool. He had slick black hair that he wore in a duck's tail. He wore pegged pants and smelled of cheap cologne. He invited me to a school dance; we danced so closely I felt his breath on my ear—it was very exciting. He took me home and gave me my first goodnight-kiss at the door and never called me again. I was heartbroken.)

During that time, there were lots of sleepovers with girlfriends, Sweet 16 parties where we danced The Twist, and fights and make-ups with best friends. We used to run home after school to watch *American Bandstand*. We knew the names of all the regulars. We were tempted to go on the show ourselves, but we were afraid we'd get bad reputations as "fast girls." On the weekends when my friends and I weren't going to parties, smoking and getting drunk with alcohol stolen from our parents, we would roam the neighborhood at night. Once we got into trouble when we robbed the donation box at the local Catholic Church. The priest caught us and we had to beg for his forgiveness and ask him to promise not to tell our parents.

There were also very sad and traumatic times like when my beloved dog Mickey died after being hit by a car. Or worse, when my father was very sick, and the morning he eventually died at home in bed with me standing next to him.

I wish I could have documented all of these moments of my youth. Of course, the memories are always with me, but it would be so amazing to have contact sheets with real images from these extraordinary years

when I was growing up and everything was changing so dramatically and so quickly.

Sometimes I have high school students in my workshops. I always tell them that they must document their friends, their lives, their relationships, sex, drugs, and everything that happens during these last years of school. I tell them it's something that they'll surely thank me for later in life.

LAURA MCPHEE

Afternoon becomes the golden hours as we cross a corner of the Great Basin in southern Idaho. Ahead of us, occasional grain elevators and windmills seem to populate the landscape; behind us lies the Great Salt Lake in its seductive shades of pastel, already a memory. The white Suburban in which we ride is full of passengers, and we move fast along the straight, black ribbon of interstate. Gold turns to blue in the long northern summer evening.

We are playing stinky pinky, a rhyming word game with difficult non-rhyming clues. The children are generally faster than the adults, the eldest has a deep descriptive sense of language. In the gloaming, we turn north off the interstate, the road still the dead straight dream of engineers and construction crews. We glide across the high plains toward the mountains. The Soldier Mountains, the Smoky Mountains, and the Pioneers seem to grow vertically from the flat land and tonight they are dark cut-out paper silhouettes against a violent sky: the color of blood on a light table. Lurid in its brilliance and uniform in its luminous malevolence, the sunset has a look I've not seen before and know I will not see again. Stones on the verge of the road are struck with gold. Almost everything else is black.

My camera, a mahogany box which takes 8x10 film, is in the back; the sheet film lies nestled in its cooler. I feel the pull to take a picture in this extraordinary light, a pull made more acute by that nagging awareness that things are never quite the same twice. I stop participating in the word game; the sound of it moves further into the back seats. I want to speak to the driver and I practice the words. In my mind I can hear myself, "Please stop, I'll only be a moment. Stop here in front of this billboard advertising those mountains and their offer of sunny, safe, happy family-style recreation. And please, hold the flashlight, hand me the lens, the dark cloth, the carpenter's level."

I think the words with urgency as I watch the billboard grow larger in the frame of the windscreen. I look across the center console at the driver. He has spent many hours with pedal to the carpet today, driving dirt roads to and from an earthwork near Promontory, Utah, where the golden stake was driven into the ground and the transcontinental railroad was completed. We'd toured downtown Salt Lake City, too, cruised first homes, thought about times before children. I look at him and think about the

two hours or more still to drive and I think I see him flagging. Ahead, in the last town we cross before the mountain pass, he will fall asleep at a red light. The eyes of elk and moose and antelope will shine from the woods as we enter the wilderness. I look at the driver's wife, listen to the collection of children. No one has eaten. Food lies forty-five minutes in our future.

"It is not too late," says the voice in my head. But I do not speak. The sound of my voice does not interrupt the river of time, does not change the flow of the action or the encounters we will have that evening. I do not intercept time by making a photograph; its pulse continues unaltered. We pass the billboard and I console myself in two ways. First, I know that most photographs taken are a gamble at best. Second and more important: I remind myself to find the pleasure in this moment, a time in which the red sky passes to black, children create unanticipated rhymes, and the stars fall closer to earth.

MICHAEL MEADS

Le Round Up, the last stop along the way for the aging drag queen, for the cirrhotic alcoholic whose meds have stopped working, for the hustler who, way past his prime, is willing to do anything, and I mean anything, for pay. There were few tourists, mostly locals who had not seen the light of day in years, drug dealers, old flowers, and my partner and I. It was fabulous, a bar crawling with the most colorful and the most down-and-out of the French Quarter, where fifteen minutes of conversation with a stranger could yield a library's worth of New Orleans history. All of them drawn to Le Round Up religiously for its famously cheap cocktails and for the ruler of this devout roost: Miss Jackie Mae.

Jackie had been in her day one of the grand dames of the French Quarter. Setting a standard for glamour, humor, and compassion beyond any of her peers, Jackie's drag performances, I had been told, were an event, not to be missed. Unfortunately, we had never had the pleasure of seeing one of these productions, being that she had retired from the spotlight ages ago. Occasionally, if Jackie was in the proper mood, she would regale us with tales from her days as a young queen, of being the belle of the gay Mardi Gras balls (very much in their infancy), or of picking up sailors (when New Orleans still received a steady supply of horny young squid), and of being the all-around hostess with the moistest, as Miss Mae often said.

Charles and I were regulars, two of her favorites, and amongst her more respectable patrons (and that's not saying much for us), so Jackie would spend most of her shift talking to us, refilling our mugs, and ignoring the other customers. God help the uninformed that made the mistake of interrupting one of Jackie's monologues for something as annoying as a drink order. This could get you thrown out of the bar and sent into alcoholic exile. Or worse, a brutal dressing down in front of the entire bar, the volume of which made one consider the very real possibility that Jackie might have been a Marine drill sergeant in some past life.

Those were the moments you lived for at Le Round Up.

It was a December in the Quarter, which means, depending on the day, cold and damp or warm and damp, damp being the operative word. As the weather had been dreary all day, I decided to leave my camera at home that night, something I rarely ever did. We were heading down to the Quarter for an evening of cocktails with Miss Mae and then finally off to

the Corner Pocket for New Meat Night (a sleep-disturbing collection of some of the most jaw-droppingly beautiful amateur male strippers and the.... not). A full evening's entertainment was lining up, by anyone's standards. Jackie was in a particularly festive mood, it being Jesus's birthday. The handle of vodka (modestly labeled VODKA) she had burned halfway through since starting her shift did not hurt either, and the entire joint seemed lifted by her good spirits. Patrons might not only get a drink, but it might even be what they ordered!

Le Round Up, thankfully, had a juke box that was delightfully out of date, stocked with everything from Dinah Washington to Captain and Tennille, and we would always sink enough dollars into it early on to insure that the night's soundtrack would be pleasing to ourselves, and even more so to Jackie. We always asked Jackie for input on selections, a courtesy that endeared us to her from the first time we bellied-up at Le Round Up. As the music played and the cocktails were being slung, and everyone was catching the third or so buzz of the day, Jackie began to dance around the bar, almost unnoticed at first, but then as Cher began to warn us of "Gypsies, Tramps, and Thieves," Jackie grabbed her bar glass sponge as improvised microphone, untied her ponytail, and began to perform a desperately energetic dance, lip-synching along with the former Mrs. Bono. Now, understand, Jackie had retired from performing many years earlier, and rarely was seen in full gear, but this was something not seen in decades. Her longtime patrons were stunned, mesmerized. The performance continued around the bar, becoming more frantic with each note until finally at song's end Jackie collapsed onto her back on top of the bar, legs pumping into the smoky air, laughing hysterically at herself for such a display. The patrons of Le Round Up rose to their feet and we all gave her the ovation that she so deserved. Easing down from the bar, and taking her bow, she said as she caught her breath, "I haven't moved like that since Moon was mayor." We had been given the honor of seeing Miss Mae's final performance.

With the show over, everyone went back to their drinks, transactions, and/or conversations, and noticing the hour, we paid our tab (what little she bothered to charge us), said our goodnights, and always with a kiss from Mae to send us on our way, we stumbled our way up St. Louis and into the Pocket.

ANDREW MOORE

A moment of opportunity can arise suddenly within the flow of time and just as quickly disappear. This perception of time's singular quality, which the ancient Greeks recognized as distinct from the regular passage of time (*chronos*), was embodied in their god Kairos. The youngest child of Zeus, and perhaps a favored son at that, his overall swiftness was symbolized by his winged feet; yet most emblematic of all, long locks of hair dangled in front of his face, although when seen from behind, he was actually bald. The meaning of this eccentric coiffure is clear: opportunity has to be grabbed as it approaches, and once it passes, it becomes all but impossible to reach back for.

Everyone, in both personal and professional experience, is familiar with moments of regret, of chances seen but not seized. But photographers might have this sensation more often than most, especially those pursuing rare and ephemeral alignments within reality, who are subjected to these tantalizing "misses" on a daily basis. There are do-overs, re-shoots, retakes, recreations, and a host of second chances, but the emotion of seizing upon the flow of time, the complete satisfaction of making the unrehearsed but perfect leaping catch can never be exactly replicated.

Although one of my earliest missed opportunities happened nearly thirty years ago, I can still glimpse in my mind those half a dozen workers in their brightly colored outfits, composed like musical notes on the skeleton frame of an outdoor highway sign, as I whizzed by on a highway too crowded to pull over. Or the building on fire in Brooklyn at dusk, the flames shooting high into the sky, with the Manhattan skyline in the background. Or an interior of an old woman's home in Cuba, enormous and decayed, with a child's swimming pool set in the middle of the grand salon.

Much in the same way that a love affair gone awry continues to revolve over and over in the mind, the lingering pangs of regret over these might-have-been pictures still trouble me. Perhaps there is no antidote, except to be ever prepared to grab the forelocks of swift-footed Kairos, while bearing in mind the advice of Henry James: "Try to be one of the people on whom nothing is lost!"

RICHARD MOSSE

I was roused at dawn in Damascus and got just my trousers hoicked hastily on as my front door was being battered open. A gang of men roared in Arabic outside. The door was being belted with something heavy like a bar stool.

I had just arrived in Syria about six hours before. There was really no explanation for what was happening. But the possible outcomes were not attractive. I weighed up my options. I could stay and negotiate with a band of shouting young Syrians whose objective was unknown. Rather than hang about, I looked for an escape route. Pumping with adrenaline, I leapt from the balcony railing to the roof of the building across the street. It was a clean six feet, five floors up. Not something a sane man would consider in the plain light of day.

I could find no way off the neighboring roof, neither by stairway or even by lowering myself onto a balcony further down. In the hopes of putting more distance between myself and the unknown, I jumped a second time that morning. This time I leapt from a sheer parapet across another street to a third building. There I found, to my shaking relief, an apartment under renovation. I slid its glass door ajar.

The sturdy exit to the stairwell was unbroachable. I made a hiding hole out of the little room being prepared for the suite's toilet. Four unhinged doors lay stacked against the wall of the alcove. I restacked them against the entrance, between me and the sound of the melee still drifting across the roofs. I had armed myself, in place of the camera, with a three-foot piece of steel rebar.

I felt as vulnerable as I was. I languished there for perhaps forty minutes, half naked in a darkened building site, hovering over unfinished plumbing. The rusty length of metal that I clung to as a weapon was a poor substitute for my recalcitrant cable release.

ZWELETHU MTHETHWA

CHAPTER ONE

The setting, a room painted in a mustard color with an olive green carpet. About nine figures sit around a dark wood coffee table with a black empty vase standing on a white doily. The mood is somber. We are discussing the funeral arrangements for my Mum. Our mother.

I ask if I would be allowed to take the last photograph. The family vehemently says, "No."

They have denied me permission to take my picture because cultural belief dictates that the body of the deceased is sacred. The body must not be documented; no image of the body must exist after life is gone.

This triggers a few questions in my mind about photography—what it represents and its reality. I think about the complexity of familial relations. Does one sibling feel the meaning of the parent in the same way as the next? If not, I still hang on to the notion that my right, as an individual, is to form my picture of my Mum outside the influence of the intricate web of her relationship to everyone else.

CHAPTER TWO

The setting, a church. My mother's coffin sits between the congregation— the family—and the altar. The coffin is open and surrounded by flowers. She is clothed in her favorite lemon-colored dress. The air is still and the congregation is singing a hymn. The reverend starts to read from the Bible and my mind starts to wander.

I try to retrieve from the memory bank of my childhood, but not a single image comes to mind of my Mum and me in church—the image being created in that moment, at her funeral, is the first and last image with which I am left today.

Her complexion has changed. She is slightly darker, but has a thin white film covering her face. I can smell the flowers, but I can't smell her. It haunts me that I cannot see her eyes—not that her eyes are closed, but that I know the window I am imagining is no longer open. The image has been altered.

As I walk away from the church, the sting I originally felt at being denied permission to take what I felt was the final image—an image that I had

seen myself holding onto as the key to unlocking my memories of my life with her—was no longer an issue. I realize that, in fact, the final image could never have been that specific photograph. The image was, and remains to this day, a nuanced and ever-shifting conglomeration of the memories themselves.

LAUREL NAKADATE

There was a day that the Southern California sunshine felt like suffocating lava and was replaced by a rainy night with a laughing and bruised hero mirage called the moon. There was a day that an airplane departed JFK and arrived into LAX, with fifty-five empty seats, any of which you could have booked, but did not. There was a day that I pulled over and cried, in my car, parked at the edge of Hollywood and Laurel Canyon and felt my fifteen-year-old shell of a Honda shake around me as everyone drove past. No one stopped to hold me or fondle me or shake me or look me over or ticket me or question me or count me in or rule me out. I had no one to pick up at the arrivals gate. I did not take a photograph that day, inside that car, stopped but not broken down, on the road's shoulder, because I felt there was nothing to preserve. Nothing to save, no one to see, nothing to remember, no one to look after me or the lonesome and failing and gliding shadows that took on water, flirted with trying, and finally surrendered, gave in, behaved, fell in line, and passed in front of the dashboard like hypnotized drone puppets on a mobile above a baby's crib. Sleep now, sleep, we need you to sleep, the world needs a break from you. I did not take a photo that day, because the clicking shutter would have been a parachute, it would have been a ripcord, it would have meant the things around me mattered.

Night fell, as it always does. The lava sun had given up like me and now swam in an ocean of twilight and blown apart stars. My heart followed suit. The canyon grew crickets that stood up bravely and announced their small two-syllable names—like spelling bee contestants. And their names were all the same. It grew cold. My blown apart heart found the keys and turned the engine over, turned the day over, turned the heat on, worried over you not coming home, again. Worried over that rainy season that was beginning, that included April in Los Angeles. Los Angeles, city where the whip snakes sleep in Runyan Canyon in the shape of licorice wheels, below the sign that begins like hope but buys too many consonants and vowels. Consequences and howls.

It began to rain and the car engine burned through the drops. I tried to wish my car into a tomb. A mausoleum. A sepulcher. I believed there was a beauty in wanting to save everyone but me. I thought of the firemen, up north, fighting the forest fires I'd watched on the news, going in bravely,

sacrificing eyelashes (magical childhood wishes you must blow away to make real), days away from their families, trying to put out the flames, trying to save someone, anyone, and finally emerging with no one in their arms. Heroes who never saved anyone. Heroes, just the same.

There is a point in the ocean, leagues out from land, that swimmers reach when the beach becomes just another homesickness to turn away from and tide pools, irrelevant telegrams talking in circles out of ear shot. Morse code is a heartbeat too faint to support more than one life it turns out, after all. The landlocked person always falls in love with someone else. The sailor elopes with a mermaid or is seduced by a siren. Text messages jumble and arrive days late, misunderstood, rowdy, underdressed and out of order when they go over their character limit and try to get down on one knee. There is a shelf, below the legs of swimmers, located on the ocean floor, which divides the place where they still have control from the place where trust might include an offering as generous as an entire body. That day, that became that night, at the side of that road, below that canyon, I trusted my body to migrate beyond midnight and into Monday. I took no pictures. I have no pictures to illustrate this story and that is exactly as it should be. The next morning, I woke up in my driveway; I'd managed to make my way out of the canyon, down into West Hollywood, and parked between my neighbors' cars. I'd slept there, in the fumbling beauty of the back seat of my car, alone beneath the residential palm trees. The sun came up like a ball of lemon taffy, I worked my way up the stairs of my apartment, lay on my bed, listened to the neighbor's television selling the morning weather, and I knew one day, I would leave you.

The first pictures I ever made were of my mother on a deck in Seattle before she left for what she claimed might be forever. The next pictures I made were of my feet in a hospital bed; I was seven. Photography has saved my life, over and over again. That night, I wouldn't let it. I needed the world to choose me, if I was meant to keep going, let down and love-less. I needed a sign.

I believe photography is about choosing to live, being brave. Looking is an act of courage. It's terrifying. It's possible to see too much, to witness things that we cannot hold. I wasn't brave that night. To record is to carry a burden, to surrender to beauty. I will never be powerful enough to save everyone. And I have to be okay with that. There is a beauty in not being

enough. Sometimes, photographs live in our hearts as unborn ghosts and we survive not because their shadows find a permanence there, but because that thing that is larger than us, larger than the things we can point to, remember, and claim, escorts us from dark into light, we emerge from the flames with no one in our arms, and we never unpack the camera.

ED PANAR

A few months ago, I was walking down the street and saw a dog strapped into a wheelchair, pulling itself along with its two front paws. I saw it again a few weeks later, leashed outside of the hot dog shop, panting with its pink tongue dangling out of its mouth on a balmy summer night. That reminded me of another dog I saw in Taipei a few years ago. That dog was small, dirty grayish-white, and kind of mangy-looking. It was standing straight up on its hind legs in a crowded city park outside of a bus station, alternately standing still and walking around in circles. No one seemed to be paying much attention to it and there was something about it that made you want to laugh out loud and cry at the same time.

The other day I was walking along a city street at dusk underneath the yellow canopy of the autumn ginkgo trees. It was a street I had never walked down before that felt pleasantly enclosed and forest-like, with rows of big trees rising above you. The sidewalk was littered with hundreds of the small golden leaves, with more sure to come as the sky was just beginning to open up between the crooked branches. At this time of day, everything is bathed in a soft blue-gray light as the buildings take on an air of quietude as if they were letting out a sigh of relief after another busy day.

I don't always take my camera with me when I go for walks. Sometimes I forget it on purpose; sometimes I have it with me but don't use it. I always felt that walking is a bit like taking pictures anyway—you only ever get a small glimpse of the infinite number of things that are around you and there will always be more that you didn't notice than you did, even in the most familiar and comfortable setting.

CHRISTIAN PATTERSON

I was driving on a remote rural road in Nebraska, surrounded by white snow and white sky, when a big, black smoke cloud appeared on the horizon. My curiosity led me to drive toward it.

I soon arrived at a small house. It was engulfed in flames. I parked, grabbed my camera, and jumped out of my car. There was no one else in sight, and it was eerily quiet. I ran toward the house.

As I approached the house, I heard it crackling, sizzling, and wheezing. The air smelled burnt. The ground rumbled. It would all be gone in minutes. Just as I was raising my camera to my eye, a truck roared into the driveway.

A man jumped out of the truck and ran into the yard. He fell to his knees, put his hands on his head, and began crying.

Helpless, he watched the fire destroy his house and everything inside it. And I watched him.

I could have easily made a photograph. Rolls of photographs. I also could have tried to console the man, but I did not know him, and I did not know how to help.

A small fire truck soon arrived—too little, too late. Several neighbors also arrived and gathered around the man, putting their hands on his shoulder, and offering support.

I returned to my car, put down my camera, and headed back out on the road, looking for my next shot.

ANDREW PHELPS

When I was in Higley, Arizona in 2006, working on my project, I would use the jet-lag to my advantage and be out working by 5 am.

My day would start with a thermos of coffee wedged between my legs as I prowled the edges of this "new urban America" in a borrowed 4x4. There are seldom surprises in such places; in fact, their very design is to keep the unexpected at a distance. Such places are summed up in four words: White, Anglo, Saxon, and Protestant.

I don't know why, but I remember the name of the street so clearly, Strawberry Lane. I wasn't expecting anyone out so early, so I was surprised to see an Indian man (Asian, not Native American) sitting in a lotus position, meditating and praying to the rising sun. He was sitting on a small patch of grass in a sterile community picnic area, neatly tucked between a plastic swing set and a covered barbecue veranda. It was one of those moments where you almost stop breathing, a clashing of so many customs, cultures, and attitudes. I can vividly remember my head wanting my foot to hit the brake pedal, but I couldn't bring myself to stop. I felt I was privy to a moment that was very private and, for this man, obviously very sacred. I continued driving, my head racing with a vision of this man who needed no more than a patch of grass and the rising sun to somehow find peace in this place that I had come to detest and criticize as being soulless, a place I once called home, no less. This man could do what I hadn't figured out how to do: transcend this mundane, lifeless place. What for me was a ridiculous picnic table veranda was his pagoda.

I was about a mile down the road before I actually stopped and turned around, hoping not to find him still sitting and meditating, but instead maybe sipping a tall latte under the veranda, chatting on his cell phone. I would drive up, make small talk, comment on how much I liked *Slumdog Millionaire*. Then he would show interest in my photo project and "get" what I was working at. We would make a date the following week where I would be able to photograph him praying...

But alas he wasn't there anymore, just minutes later. For the next two years, every time I was back in Higley, I would purposefully drive down to this corner, hoping to see him again, not only to finally ask him for a portrait, but also to prove to myself that it wasn't an illusion.

I never saw him again.

SYLVIA PLACHY

I am shy. I thought as a photographer I could hide behind my camera and, though sometimes I can, still I had to learn to overcome my reluctance. Years ago, when Guy Trebay and I were a writer-photographer team for *The Village Voice*, a weekly newspaper in New York City, there were occasions when I couldn't walk up to a person to take his picture. Those times, Guy would taunt me with, "Diane Arbus would do it." I did it then and I often do it now, still hearing his voice in the back of my head.

During the 70s, 80s, and 90s, as a staff photographer, I've explored the many moods of the City and have also been sent on assignments to troubled spots like Three Mile Island to cover the effects of radiation, and to Nicaragua shortly after the war there. In Kuwait, I heard the rumble of fires burning in the blackened desert under a cloud of suffocating smoke. In 2005, on a mission for Women for Women International, I listened to women in Rwanda and Bosnia tell their stories of massacres they had witnessed and rapes they had survived, and I visited a hospital in the Democratic Republic of Congo where every day the courtyard is filled with women and children who were raped the night before.

I've seen a lot, and as a photojournalist each time I'm sent somewhere I try to bring back an image that is the essence of what I saw and felt.

It was a glorious autumn morning. I was working on a "day in the life" kind of assignment in Manhattan, following Fergie, Duchess of York, around the city for a British magazine. While she was in the studio being interviewed by Diane Sawyer of *Good Morning America*, I was alone in an upstairs hallway. I stopped by an open door. The room was empty. It looked like an art installation in a gallery. There was no furniture, only a TV, and it was on. The sound was off and on the screen a sci-fi film seemed to be playing. I watched in silence as a plane sliced off the top of one of the towers of the World Trade Center. I could barely comprehend what I was looking at. I turned up the volume. Slowly it dawned on me—it wasn't a movie at all, it was a newscast. The reporters didn't understand either, they kept replaying the clip over and over again until the second plane hitting the second building made it clear—it wasn't an accident.

This was of course September 11, 2001. By the afternoon, I was relieved of my assignment. Fergie was whisked into hiding and I was free to follow my photographer's impulse and head toward the disaster. The streets

were empty of moving cars. Cabs went home to Queens, subways and buses stopped running, a sea of people filling the width of Sixth Avenue was rushing toward me.

Below 42nd Street, a large man stood out from the crowd. His whole body was covered with white powder. Walking with the hollowness of a mechanical doll, or someone in a trance putting one foot ahead of the other, his whole being expressed the shock, the horror, and the incomprehension and vulnerability we all felt. He was all of us. He was the picture. It was his face that struck me most—his eyes, unseeing, wide open like a man who had walked through hell, and his dark skin smeared with a chalky substance, a mask of tragedy. He was the icon. I wanted to take it. I would have had to step in front of him, interrupt his frantic pace. I felt ashamed, I hesitated, I questioned. It didn't seem right. In an instant he was gone. I didn't do it.

Every day for two weeks, I returned downtown and searched and never found another picture as powerful as that. His image haunts me to this day. Diane Arbus would have done it.

MARK POWER

The picture I didn't take happened, or rather didn't happen, in Gdańsk, Poland in 2004. I was working on *Eurovisions*—a Magnum group project, ten photographers, one to each of the countries that joined the European Union that year. It was to become the foundation of a much larger individual project, *The Sound of Two Songs*, which I eventually completed in 2009.

We (my assistant Konrad and I) had been granted access to the Gdańsk Shipyard (Stocznia Gdańska). Better known in the west as the Lenin Shipyard, it is infamous as the birthplace of *Solidarność*, or Solidarity, led by the moustachioed electrician who would one day become president of Poland, Lech Wałęsa.

When I was a student, way back in 1981, I had sold *Solidarność* badges on the streets of Brighton, my humble attempt to support the striking dockers. I well remember the chilling image of General Jarulzelski, broadcast one evening on BBC news, as he slid into a battered chair behind a cheap brown desk to announce the imposition of martial law.

And so it was with great expectation that I entered the shipyard on that cold November morning. We were accompanied by a security guard, soon to be joined by another, then another, until a small team of uniformed and curious onlookers formed our band—so many that we had to travel around the site by minibus.

We were taken to Wałęsa's original workshop, preserved in the grime of two decades, and a memorial dedicated to workers killed in the uprising. We happened upon the original *Solidarność* office, a painted banner still hanging outside. And we toured a vast network of almost empty factory buildings, rusting cranes, and a selection of what appeared to be aging tugboats sitting in dry dock. The shipyard, sadly, was working at just 25% capacity; now operating in a capitalist, competitive system, it was unable to compete with the Chinese.

I was allowed to photograph whatever I liked until a sharp-suited woman appeared and the convivial atmosphere changed. Immediately suspicious, she demanded an explanation for everything I wanted to point my camera at. Still, we were nearing the end of the day, and I had already made a number of exposures I knew I'd be happy with.

As we drove to the final part of the site, I saw through the greasy window of the bus an ancient Soviet-style steam train, laid to rest in a sheltered siding. The golden, late afternoon light exaggerated the iridescent red ochre dust that covered the machine like a blanket of rusty iron filings. It was exquisitely beautiful, and utterly breathtaking.

I gasped, and requested, urgently, to stop. I *pleaded* for us to stop, refusing to believe what I was hearing...

"No, not that, definitely not that."

But why not? Why not?

"No, not that."

And there it was, gone. No rhyme nor reason for refusing me... just a whim. It was all I could do to stop myself acting like the spoilt child refused the last and best sweet in the bag. I just wanted to get out of there, or I wouldn't be held responsible for my actions.

Some years later, I was reading one of Enid Blyton's *Famous Five* books to our youngest. The adventure told of a "ghost train" that entered a tunnel and then strangely disappeared. Of course, Julian, Anne, George, Dick, and Timmy solved the mystery, discovering a secret chamber where the train, used for smuggling stolen goods, was stored during the day. It, too, was covered in a strange dust.

PETER RIESETT

The light was perfect, the scene deep with emotion and rich with meaning—a photographic opportunity that might well have defined "the packing up of a life." But I could not impose on the moment.

I was standing in my grandfather's office when I noticed, across the hallway, my grandmother seated on the corner of her bed—an old shoebox in her lap. The fading sunlight of that spring afternoon streamed in from her bedroom window, tenderly illuminating just how lost she was in that simple box of memories. I could sense the past, present, and future passing before her eyes—reminiscing and agonizing, as she undoubtedly was, about the soul mate no longer here to share her life.

The ache I could sense in her heart tugged heavily on my own. Part of me wanted to wrap her in my arms and tell her everything was going to be all right. And another part of me wanted to catch that moment forever on film. I did neither.

This was my second grandfather to have passed away and the second time I was documenting "the packing up of a life." The difference here: this grandmother was still alive—a poignant presence mourning the loss of her husband of sixty years. Unbeknownst to her, my grandmother and I bonded forever in that instant. Perhaps some images are meant only for the mind and the heart.

JOSEPH RODRIGUEZ

As a Latino growing up on the tough streets of New York City, I wanted to speak about issues that were affecting my own culture: family, poverty, addiction, religion.

I had been working on a long-term documentary book project on Spanish Harlem when I met Peter, Yvonne, and their four children. They were poor and using and dealing drugs like heroin and crack cocaine. Although their situation looked bleak and dire, there was still a sense of love for their children even as they struggled with their addictions.

For over two years, I had been photographing the Rodriguez family (no relation). One day, as I entered their small one-bedroom apartment with two cats, a dog, birds, and their four kids, Yvonne and Peter were in a heated argument. Crack can make people very erratic and violent. My immediate response as a photojournalist was to document this terrible moment that was unfolding in front of me. I can remember clearly, as I continued to raise my camera to my eye, Yvonne staring and whimpering in desperation as the tears flowed down her face like a waterfall, her eyes bloodshot. I immediately checked myself and realized that I had to do my best to curtail this horrible moment of anger that Peter was trapped in. So I grabbed Peter and pulled him out of the house. We walked and walked, grabbed a beer, and as he began to calm down, I began to counsel him.

You see, I can remember my mother and my heroin-addicted stepfather arguing and fighting many times during my adolescence. One day, I tried to stop him from hitting my mother, but I was only a boy of ten years old, and I was no match for his strength.

As an ex-addict myself, I am all too familiar with the demons that hover over the addict and continue to destroy so many families. It is these experiences that have made me the photographer I am today.

STEFAN RUIZ

For about seven years, starting in the early 1990s, I taught painting and drawing to inmates at San Quentin State Prison in California. It was my first teaching job. I had also just started to do photography. I was living in Berkeley and drove to the prison one to three times a week. I taught mostly on the "mainline" (the general prison population in the main part of the prison). But occasionally I taught other guys in other parts of the prison—including death row, the H unit, and the ranch (minimum security).

I had a pass that let me go through a lot of the prison. I could draw keys to many things including the tiers on death row. I saw all kinds of things and met all kinds of people. Many of my students were in my class for years.

My class had anywhere from five to fifteen guys in it depending on the day. Most of them were older than me and pretty much all of them were a lot bigger than me. There was no guard in the room. The nearest guard was in a small building about fifteen yards away called "The Max Shack." This was essentially a check point that divided the cell blocks and the upper yard from the administration buildings and the stairs that go down to the lower yard. I had a whistle that I was supposed to blow if there was any trouble in my class but I always figured whatever was going to happen would be over by the time the guards got there.

The class lasted at least three hours. In no time, I went through every lesson I knew from art school. So we started doing portraits. It was something I was interested in, and if the inmates could draw or paint a portrait they could make money. Portraits were needed in the prison and inmates weren't allowed to have cameras—so it was a bit like before the invention of the camera. And the inmates had time.

The art room was a converted laundry room next to the dining hall. Inmates lined up to go into the dining hall on the edge of the upper yard right in front of our door. After eating, many of them hung out in the upper yard. Someone from the class would pick an inmate from the yard and get him to sit for us. There were all kinds of guys who posed. I have at least fifty portraits that I drew or painted over the years I taught there. Some of the portraits I like a lot, but, of course, I always wanted to have my camera with me.

I was able to take my camera into San Quentin maybe fifteen times in my seven years there, and I was allowed to take pictures with many restrictions. But for most of the time I was teaching there, I was a frustrated photographer in a visually amazing place with all these great subjects, and I couldn't take a picture.

MATT SALACUSE

As a photographer, you are judged on only one criterion: having taken a photo. Everything after that is subjective bullshit. So, having not taken a picture of something makes you no longer a photographer but more a slack-jawed gawker. That's what sets photographers apart from eyewitnesses: we have a camera. It is like how Garry Winogrand described photojournalism: "f8 and be there."

In the mid 1990s, I was there, trying to become a photographer, carrying a starter Pentax K1000 wherever I went, just in case "there" was where I was. One night, I went to meet my father, who was staying at the Ritz Carlton. As I waited in the lobby, I saw my opportunity to become a photographer and not a gawker. My aspirations were as high as Robert Capa's on D-Day, but my shot at soldiers storming the beach would come in the form of celebrity couple Tom Cruise and Nicole Kidman with their newborn, adopted baby. You must think back to a time when celebrity sightings were pretty scarce and celebrity couples did not receive cute nicknames. I could see visions of my photo exclusive of this newborn in the arms of Tom Cruise and his wife, with the headline "Celeb Photog Snaps Cruise And Baby, Saves World."

So I slip outside where I know they will be headed for a waiting limo. I turn my back to the door that they will be coming out of and look down at my camera's settings: f8. Perfect. Here they come. As I peer over my left shoulder to see where they are and where I should preset my manual focus camera, Tom Cruise is standing only four feet away and looking right into my face. He lowers his chin and looks into my eyes and says, "You're not going to do that." It must have been some crazy Scientologist voodoo mind trick, because I looked at him and said, "You are right. I am not." And I didn't.

I don't know if he sensed that I was not that type of paparazzi person or that I had seen *Top Gun* over a dozen times and that I wouldn't go below the hard deck just to get the shot, but it worked and all I have to show for it is the story.

ALESSANDRA SANGUINETTI

Every day I take at least two imaginary pictures between my thumb and forefinger, especially of my daughter Catalina, friends, and family. Mostly people and places I don't want to interrupt anymore, don't want to feel separate from or gaze at with any more melancholy than I already do.

Today Catalina was standing on the balcony overlooking the park and river here in Buenos Aires, and the sun had set. The light was blue but not yet flat, she was pointing at the moon, and the horizon had a violet line across it. I started to go back inside to get a camera, and then stopped and clicked with my fingers.

However, I do have a very real list in my mind of the photographs I never made and will always wish I had.

The eternal hare darting in front of my pickup truck at night.

The two white horses always grazing at the same spot right before the bridge. I see them every time I drive back to the farm at night and have never stopped.

The winding dirt road illuminated by the full moon.

The cheap hotel lobby I passed every day this week walking to dinner, each night with a different scene: last night, three shirtless men playing cards and a little girl lying on a couch facing the fan. It was very hot.

Belinda's wedding.

In Buenos Aires, three street kids standing on a heat grate, laughing, with their hair flying straight up and trash, wrappers, and cans flying up, going round and round. Big happy smiles.

Two months ago, Belinda, her two-year-old son, and her mother standing in front of her father's niche, struggling to unstick dried flowers from the vase and caressing the small oval picture of him.

Everyone sleeping. But really sleeping—not making believe.

Everyone waking up.

December, early Sunday morning in town. A very young volunteer fireman in a huge oversized uniform selling us a two-peso raffle ticket to collect

funds for new uniforms. Big smile with giant crooked teeth and flapping arms lost in giant sleeves.

My older sisters dressed up for carnival in the town of 25 de Mayo, when I was nine.

Sunset, gray light, 1978, my father's carrying a transparent plastic bag with our dead dog to its grave under the willow tree.

A mosquito freshly crushed on Juana's leg.

Last night. Guille, her baby, Belinda, her husband and son watching the last carnival parade of the summer in their small town, throwing fake snow at each other and dancing. I missed them; they said, "Oh, Ale, we were there and it was great!" Why did I assume they weren't going? It was also my last night there.

Tomorrow I'm on a flight back to New York. I'd like to photograph that plane taking off from down below on firm ground.

JAMEL SHABAZZ

There have been a few occasions when I would second guess my own judgment in approaching a complete stranger with the proposition to record their history. One particular moment that I think of often happened about ten years ago during one of my many visits to the vibrant city of New Orleans. I decided to beat the extreme summer heat by getting up early to celebrate the beauty of the morning sunrise. I had been staying at the Marriot hotel (a special birthday present from my wife), and I vividly remember the excitement of being up early to capture this golden time of day, as I traveled to Lake Pontchartrain with my Nikon 8008 in tow and a fresh roll of Ilford hp 400 black-and-white film.

The park was empty except for a silhouette of a figure I saw some distance away. As I continued on the path, slightly blinded by the brightness of the sun, the figure started to become much more apparent. It was a shirtless, bald-headed white male in his early 20s who appeared homeless and in his own world. As I got closer to him, I looked into his youthful face and was shocked to see a large black tattoo of a Nazi swastika etched in the center of his forehead. He seemed totally oblivious to my presence and, despite having my camera properly set and at the ready, I was unable to muster the words out of my mouth to this young man, who seemed to be in an internal battle with himself.

I have confronted so many unique individuals during the course of my travels, but never had I come across someone like this. To have captured that image would have been one of my most compelling portraits ever. In retrospect, I know that if I had engaged him with humility, sincerity, and perhaps a few dollars for something to eat, I would have been able to convince him to stand in front of my lens, so that his presence could be documented, and maybe even talk to me about the tattoo. There is no question in my mind about my ability to have made that photograph that day and I vowed from that point on that I would never again hesitate to confront a subject.

Despite the fact that I didn't get a chance to record that "Forrest Gump" moment, memories of that day are still etched in my mind. So that I never forget that point in time, my hope is to find a skilled sketch artist to recreate that once-in-a-lifetime moment when two opposite worlds crossed.

ALEC SOTH

If there are "home" photographers and "travel" photographers, I'm most certainly the latter. As much as I admire the intimacy of artists like Nicholas Nixon and Sally Mann, I find it almost impossible to photograph anyone but strangers. And while I'd like to make pictures where I live in Minnesota, I usually have to travel in order to find my eyes.

When my wife and I went to Bogotá, Colombia, to adopt a baby girl, I had no intention of doing a photographic project. On the day that we were to receive our daughter, I decided to shoot video instead. I set up the cheap camera on a tripod and pointed it to the location where we were standing in the orphanage. On the recording my wife and I are seen smiling nervously with anticipation. You hear a nurse walk into the room, my wife shrieks with joy, opens her arms, and we both step out of the frame. The single most remarkable event of our life was documented only in audio. Perhaps the mystery only makes it more meaningful.

We ended up spending two months in Colombia. With this unexpected time on my hands, I decided to make a photographic album for our new daughter. But I was unable to take serious pictures of my baby and wife and the new bond forming among us. I needed to walk the streets in order to make pictures. But even though I photographed street dogs and strangers, every picture was an attempt to see my child.

AMY STEIN

My husband John is extremely camera-shy. And because I am a photographer, it can become quite a problem when he refuses to allow me to take his picture. No matter how nicely I plead or sternly I insist that he pose for a picture, my entreaties are met with dogged refusal and silence. It doesn't matter if I am just grabbing a snapshot—which happens rarely for me—or trying to set up a more formal portrait, when I raise the camera to my eye, he makes a face or dodges out of the frame.

My mother was an avid amateur photographer. She took pictures constantly of my father, myself, my friends, and our extended family. One year, she documented every room in our house. To pore over the photographs as an adult, rediscovering little details of space and time from a moment in my childhood, is a revelation and a joy. Although she made thousands of images, she was always behind the camera and rarely in front of it. I have very few photographs of her, and I feel this loss whenever I yearn to pore through old snapshots to remember who I am and where I came from. I often wonder about the many, many images I will never make of John. What they may have looked like individually and how, over the years of our marriage and our life, the absence of these images will affect the way that we remember how we were. They could exist but they don't. They exist only in memory and the past.

MARK STEINMETZ

When I was nine, I wanted a fish-eye lens. This was around 1970. While perusing a photography magazine, I came across an ad—it was a monthly contest really—a lens manufacturer was offering a free lens if you would write to them and describe your "dream image." If yours was selected, they would arrange for one of their photographers to set up and shoot the scene you described. The picture would then appear in the next month's issue and you would be sent your free lens. You don't see ads like those nowadays.

The dream image I sent in was this: to lie down in a meadow with your back flat to the ground during a thunderstorm. You'd need to photograph looking straight up at the sky with a fish-eye lens. You would need ample lightning, shot with a slow exposure. Ideally, the lightning would radiate from the center of the image. Also, it really would be best if there were trees ringing the meadow—these would show up nicely at the edge of your circular picture. The photograph would end up looking kind of like a blood-shot eyeball. I even made a drawing for them.

Around this time, as I was waiting for my dream image to appear in the photography magazine, I ordered a submarine from the back pages of a comic book. My mother gave me some change for vacuuming the house and I had a tiny weekly allowance—so I scotch-taped my coins to my letter and sent it to the submarine maker. The ad for the submarine described it as being big enough for two people and I actually thought I'd be able to navigate Boston Harbor in it. It came in a large flat package and it turned out to be constructed of cardboard. I folded it up and it became a submarine-shaped box with submarine décor on the outside. You could get inside it. It had a periscope with two angled mirrors and a torpedo tube that resembled the cardboard tube you're left with when you've used your last paper towel. You'd put your mouth on one end of the tube and blow out a plastic torpedo. At first I was disappointed, but when it was all assembled I thought it was neat enough. I went out a few times in my neighborhood on my own and once or twice coaxed a friend to come along with me. There was an opening at the bottom for your legs so that you could walk around while your upper body was concealed. The scene I made must have resembled the great 1944 Central Park photo by Kertesz ("Homing Ship") where all you see are legs—the boy's torso is covered by

the white sails of his toy ship. I wish I could go back in time and photo-graph my childhood.

They never did publish my dream image or even get back to me about it. I've never made a photo with a fish-eye lens. Later in life I did manage to photograph cloud-to-ground lightning while driving down a Mississippi highway at high speed. In many ways, the nine-year-old I used to be still calls the shots in my life and work.

BRIAN ULRICH

The list of photographs that I am missing while I sit on airport runways, teach classes, or spend hours in the studio makes my head spin. It's almost as if I can actually sense all the great pictures that I'm missing at a given moment. It's times like those that remind me to be *very* productive when I do get behind-the-camera time.

One notable miss was while photographing thrift stores last year. On a trip to Columbus, Mississippi, I had one morning to find and photograph a large thrift store that functioned to fund an orphanage. Whenever I show up at a new store to photograph, I usually spend some time taking pictures of the piles, the still lifes, and the environment before I settle down to make a few portraits. This allows people to not only get somewhat used to the large old camera, but also I can spend some time watching people and begin to think about the eternal portrait question: what do I want the person in the picture to do?

As my hours dwindled, a young boy of about nine who worked at the store repeatedly came by to ask, "Can I help you?" Each time I would explain that I was visiting the store to make some pictures and that I had already spoken with the management. The boy, whose face was half covered in some bubbly orange sugary confection remnant, seemingly could not remember five minutes ago and, with each passing, had to stop and ask, "Can I help you?" "Pickedchures?" "A camera?" Maybe he was simply entranced by the image on the ground glass, but each time I showed him the reflected image and explained how a camera works ("My eye is like a camera...?"), while warning him to not touch the lens ("You wouldn't want to touch your eye would you?").

There was something about this kid, his innocence and him working long days in the thrift store with an unlimited supply of Nerdz, Pop Rocks, and Cheetos, that I was transfixed by. Do I take his portrait with Cheetos drizzle all over his face? Should he be carrying donations into the vast pile of trash bags filled with clothes? As my ride out of town sat in the parking lot ready to move on, he made a last pass, "Can I....?" I felt so much emotion for this kid, I could do nothing, I felt insignificant, and most of all, I could not figure a way the photograph would not belittle him.

I am haunted by this experience and toss and turn over the portrait that could've been. I've even scheduled time to take a trip back down to

Mississippi to see if he's still there, but I never do, as I'm sure that I would simply be standing in the same place and come to the same conclusion. Luckily there are more portraits to make.

PETER VAN AGTMAEL

There is a moment from my first trip to Iraq in 2006 that has lingered in my memory with a deep sense of regret. I was twenty-four and not very self-possessed. I was desperate to be at war but for reasons I didn't really understand. I was immature and creating certain potent myths about myself that focused on noble ideals and self-sacrifice and glossed over insecurities and vainglory.

It was on a patrol in Mosul with the U.S. Army. The unit's chaplain had joined us in the armored personnel carrier, and on the ride to the patrol point, he small-talked about how upset his family would be if they knew he was going out into the streets. He admitted there was no reason to have joined us, but he was getting bored back at the base.

The patrol disembarked on foot at a large cemetery in a hostile part of town. There were some gravediggers around, some studiously avoiding the patrol while others gawked at it. There weren't enough soldiers to have a constant presence, and patrols may have only been through the area a few times. After about thirty minutes of wary walking, the patrol stopped to radio in their position. The chaplain sidled over to a small enclosure, unzipped his pants, and began urinating. I noticed the scene just as he was finishing. The frame was perfect. The humps of the graves, the chaplain facing the bright wall, legs splayed, back to the camera, a large dark patch of urine dripping down, mottled light straining out from heavy clouds.

He zipped up, turned around, and declared it a "holy piss." As I gawked, rivulets of urine snaked onto the sun-baked hump of what was clearly a child's grave. The patrol moved on. I don't know why I didn't photograph the scene while it was happening, nor the aftermath. I think I was just a coward. At the time, I still had pretty conflicting feelings about the war, but if there was any good that came from that incident it was a stark realization of the odious nature of the American enterprise in Iraq and the insight that even its spiritual leadership was not immune to its dehumanizing effects.

MASSIMO VITALI

Like every photographer with a certain amount of experience, I made myself a rule (which I often overlook) that when you see something interesting you have to shoot it at that very moment. One can be tempted to wait, but the day after, something will have happened—the weather will not be ideal, something will have moved, you cannot park the car—the bottom line is, when you see something, you should shoot it immediately, never thinking that tomorrow could be better, because it will almost always be worse.

This may be my rule of thumb, but I have many interesting instances where ultimately I could not take the picture I wanted to take. It may seem strange, but a long time ago I even ended up in jail for not having taken a picture that the judge said I should have taken, although I don't want to rehash these sad and painful stories.

A funnier instance happened when I was doing some shots in Pisa, in the Piazza dei Miracoli. I had the leaning tower behind me, and was shooting the dome and the grassy piazza, which in summer is jumping with people: newlyweds, tourists, or just about anybody posing for the traditional "holding up the tower" picture. I was on top of my tripod with my 8x10 camera, and after waiting for a few hours, I got a couple of shots that I considered good enough. Happy with the day, I started to close up shop—I removed the lens, put the film away, and began to close the camera. Of course, at that very moment, I see this fantastic thing happening right in front of me. A Japanese businessman is walking with a little leather suitcase on the path leading directly to the center of my picture. A gypsy woman with a young kid in her arms goes up to him while another toddler manages to take his wallet. All this happened in a second, but I have it stamped in my mind as if it took two minutes. It took another two minutes for the man to understand what had happened, even though I already realized his dilemma, and it could have been a lovely shot that I never took.

HIROSHI WATANABE

Before I went to North Korea, I was told by everyone that I would not be able to go there as a photographer and that I wouldn't be able to take any photographs unless I faked my occupation and went there as a tourist, sneaking snapshots with a small camera. I did not feel right about doing so, and I applied for a private tour as a photographer. One month later, I received a call from the agency that my visa was approved. Since I was going there as a photographer, there should be nothing to hide about taking photographs, and I decided to bring my usual Hasselblad. It would be better to be obvious than to be sneaky—people there might actually trust me, I thought. I hate lying anyway. So, I flew there with a heavy camera bag and 100 rolls of 220 negative color film.

After arriving at the Pyongyang Airport, I was greeted by a tour guide who spoke very good Japanese. Immediately after introducing himself, he asked if I had a passport, so I handed my passport to him. He briefly looked at it and he put it in his chest pocket and said, "I will hold onto it so that it can be kept safely until you come back to this airport." During the entire time I was there, there were three men, two tour guides and a driver, who stayed with me all the time. I was told not to go out of the hotel without them.

From the beginning, everywhere we went, I wore my Hasselblad around my neck and walked around and took photographs as if that was expected of me. Surprisingly, there were almost no restrictions. I was able to walk around freely and take photographs as I pleased. But they were always behind me and watching my every move carefully.

Everyone was wearing Kim Il Sung badges in North Korea. I wanted one as a souvenir and asked my guide where I could buy one. I was told that it was an important symbol of the North Korean people and was not for sale. One had to be a North Korean to be given one by the government. Just to double-check, I asked another guide the same question, and the answer was exactly the same.

Toward the end of the trip, I was suddenly taken to a meeting room of another hotel, and there was a serious-looking government officer whose position, I was told, was director of outside affairs. The room was filled with tension, and the guides looked nervous. Across the long table, he started to make a speech in Korean. The guide translated—"People around the world are not getting the truth about our country and our dear leader, and they

are getting the wrong image about us. Please take true pictures and show them to everyone outside." He then walked up to me, pinned a Kim Il Sung badge on my chest, shook my hand, and left. Only after that did I realize that I had not taken pictures of what had just happened. They would have been intense pictures if I did. Why didn't I? Was I too scared? No. I know what he meant by "true pictures." But I would not let anyone tell me how to make true pictures. I look with my own eyes and I make true pictures when I see them. But, I wonder, "Why didn't I take his picture?"

ALEX WEBB

Sometimes not taking a photograph can be as problematic as taking one.

In 1979, I was wandering the streets of Kampala, Uganda, at a time of considerable political unrest. I came upon a sign with the word "Subway" written on it, half hidden in some tall weeds, with no mass transit station in sight. Thinking this was amusing, I started to raise my camera to my eye, and then thought better of it—after all, it wasn't particularly funny. As I turned away, I noticed, out of the corner of my eye, a group of soldiers rushing down the street toward me. With a sinking feeling, I ambled off, pretending nonchalance. Behind me, I heard the sound of scuffling boots and the ratcheting of the catches on Kalashnikovs. I turned around to face six furious soldiers. Screaming at me, they made me kneel on the ground and threatened to kick me, claiming mistakenly that I had photographed them. A moment later, they marched me off to the Nile Mansions Hotel, a site notoriously used—a year earlier during Idi Amin's reign—as a torture center. I was terrified.

When we finally reached the hotel, an officer demanded my passport, my press credentials, and the roll of film in my camera, haranguing me for photographing the military, a charge I repeatedly denied. After I had waited anxiously for about an hour, the officer unexpectedly said I could go. Handing me back my documents, he asked for one last thing: a round of drinks for the officer and his men. Relieved, I acquiesced. Looking back, the only detail I recall of our drinking together is a rather mundane but somewhat ironic one—I remember thinking that these $12 beers were actually costing me $1.20, since I'd exchanged my money on the black market. Finishing my beer, I stood up to leave. As I headed toward the door, the officer jumped to his feet and rushed to my side. Putting his arm around my shoulders, he asked me to stop by again and visit him and his men, as if we were old friends. I said I would. Not surprisingly, I never did.

REBECCA NORRIS WEBB

In the fall of 2008 during Alex's and my last trip to Cuba for the book *Violet Isle*, I was photographing a pair of pet coatis—those raccoon-like creatures that are often hunted in Cuba—on the outskirts of Havana. A man, whose name happened to be Fidel, came up and announced: "I have just the animal for you to photograph—an antelope." In the fifteen years I'd been photographing in Cuba, I'd never heard of—much less seen—an antelope. Intrigued, I told Fidel I'd call him the next day.

So, two days later—not to mention some twenty phone calls, three cars (including one with a flat tire), two different drivers, and a good three-hour drive through the Cuban countryside—we finally reached our destination. At the communal farm, Fidel got out of the car, and headed towards the unusually large barn. About ten minutes later, he returned. "I'm afraid I have some bad news to tell you," he said. "It seems someone has eaten the antelope."

BIOGRAPHIES

Dave Anderson

Dave Anderson is a photographer and filmmaker. He also fancies himself a "backroads champ," though he has no basis upon which to make this claim other then a convincing mileage gauge and a car bathed in dust, detritus, and dead bugs. He has two books, *Rough Beauty* and *One Block*, with another on the way, and he also directs video series called "SoLost" and "Southword" for the *Oxford American* magazine and National Public Radio.

Timothy Archibald

Timothy Archibald is a photographer living and working in San Francisco. He is the author of *Sex Machines: Photographs and Interviews* (Process, 2005) and *ECHOLILIA / Sometimes I wonder* (Echo Press, 2010). His photographs have been exhibited at the Catskill Center for Photography in Woodstock, New York; Zephyr Mannheim Gallery in Germany; Videotage in Hong Kong; and the Museum of Sex in New York City. He lives with his wife Cheri and sons Eli and Wilson.

Roger Ballen

Roger Ballen was born in New York City in 1950. He has lived in Johannesburg, South Africa, for the past thirty years, during which time he has produced eight books and had numerous exhibitions throughout the world. He is currently working on a new book featuring birds in a strange, surreal environment. He is represented in the United States by Gagosian Gallery in New York City.

Thomas Bangsted

Thomas Bangsted was born in 1976 near Copenhagen, Denmark, and currently lives and works in Brooklyn, New York. He works with photography and creates meticulously composed pictures that examine the medium's capacity to imagine and articulate the interstices between human and natural infrastructure.

Juliana Beasley

Juliana Beasley is a documentary/fine art photographer based in New York City. She is the author of two photography books: *Lapdancer* (powerHouse

Books, 2003) and *Sete #10. Juliana Beasley* (Images En Manoevres Editions, 2010). Beasley's style is intensely personal. An intimacy, pathos, and ease with her subjects is manifest in all of her work. Presently, she is finishing work on a long-term project about people living on society's edge in a neighborhood on the Rockaways, a peninsula in Queens, New York.

Nina Berman

Nina Berman is a documentary photographer with a primary interest in the American political and social landscape. She is the author of two monographs: *Purple Hearts: Back from Iraq* and *Homeland.* Grants and awards include a New York Foundation for the Arts fellowship, an Open Society Institute grant, and several photojournalism awards. Exhibitions include the Whitney Museum 2010 Biennial, the Milano Triennale 2010, and Dublin Contemporary 2011. She is a member of the Amsterdam-based NOOR photo collective. She was born and lives in New York City.

Elinor Carucci

Elinor Carucci was born in Jerusalem and her work has been exhibited worldwide, including solo shows at Edwynn Houk Gallery, Fifty One Fine Art Gallery, James Hyman, and Gagosian Gallery, among others, and group shows at the Museum of Modern Art and the Photographers' Gallery. Her work is included in the collections of the Museum of Modern Art, the Brooklyn Museum of Art, and the Museum of Fine Arts Houston. Carucci was awarded the Guggenheim Fellowship in 2002 and has several published monographs, including *Closer* and *Diary of a Dancer.*

Kelli Connell

Kelli Connell's body of work entitled "Double Life" has been included in numerous solo and group exhibitions. Her work is in the collections of Microsoft; the Los Angeles County Museum of Art; the Columbus Museum of Art; the Museum of Fine Arts, Houston; the Museum of Contemporary Photography, Chicago; and the Dallas Museum of Art. Recent publications include *Double Life* (DECODE Books), *Vitamin Ph: New Perspectives in Photography* (Phaidon), and *Photo Art: The New World of Photography* (Aperture).

Paul D'Amato

Paul D'Amato was born in Boston and is currently a teacher at Columbia College. After receiving an MFA from Yale, he moved to Chicago, where he discovered the communities of Pilsen and Little Village. The pictures and writing D'Amato produced there over the next fourteen years were made into the book *Barrio* (University of Chicago Press, 2006). He has been awarded numerous grants and fellowships including a Guggenheim Fellowship, a Pollock-Krasner Grant, and a Rockefeller Foundation Grant to Bellagio, Italy.

Tim Davis

Tim Davis is an artist and writer living in Tivoli, NY, and teaching photography at Bard College. *The Upstate New York Olympics*, his latest video project, is showing at museums throughout the US. His work is in the collections of the Metropolitan, Whitney, Guggenheim, Walker, Hirshhorn, Brooklyn, Baltimore, and many other museums.

KayLynn Deveney

KayLynn Deveney splits her time between Albuquerque, New Mexico, and Belfast, Northern Ireland, where she is a lecturer in photography at the University of Ulster. She has earned both a master's degree in documentary photography and a Ph.D. in photography from the University of Wales, Newport. Her work has been exhibited in group and solo shows internationally and is held in permanent collections including the Museum of Contemporary Photography in Chicago; Light Work in Syracuse, New York; and the Portland Art Museum in Oregon. Her first photographic book, *The Day-to-Day Life of Albert Hastings*, was published by Princeton Architectural Press in August 2007.

Doug DuBois

Doug DuBois's photographs are in the collection of the Museum of Modern Art in New York, the San Francisco Museum of Modern Art, the J. Paul Getty Museum in Los Angeles, the Museum of Fine Arts Houston, the Library of Congress in Washington, DC, and the Victoria and Albert Museum in London. He has received fellowships from MacDowell Colony, Yaddo, the National Endowment for the Arts, SITE Santa Fe, Light Work, and the John

Gutmann Foundation. DuBois has exhibited at the J. Paul Getty Museum in Los Angeles; Higher Pictures and the Museum of Modern Art in New York; SITE, Santa Fe; New Langton Arts in San Francisco; PARCO Gallery in Tokyo, Japan; and Voies Off in Arles, France. A monograph of his photographs titled *All the Days and Nights* was published by Aperture in 2009.

Rian Dundon

Rian Dundon is an independent documentary photographer and writer from Monterey, California, whose work has been exhibited at the Camera Club of New York, Angkor Photo Festival, Caochangdi Photo Spring, and New York University. His words and photographs have appeared in *Time, Stern, Newsweek,* and *Out* magazine. Dundon is a contributor to New America Media in San Francisco and speaks Mandarin Chinese.

Amy Elkins

Amy Elkins was born in Venice Beach, CA, and received her BFA in Photography from the School of Visual Arts in New York City. Her work has been exhibited nationally and internationally, including Kunsthalle Wien in Vienna, Austria; the Carnegie Art Museum in California; and the Minneapolis Institute of Arts in Minnesota. Elkins is represented by Yancey Richardson Gallery in New York, where she recently had her second solo exhibition.

Jim Goldberg

Jim Goldberg's innovative use of image and text make him a landmark photographer of our times. He has been working with experimental storytelling for over thirty years, and his major projects include *Rich and Poor* (1977-85), *Raised by Wolves* (1985-95), *Nursing Home* (1986), *Coming and Going* (ongoing), and *Open See* (2003-present). Goldberg's work is consistently presented as a layered, sensory experience that overwhelms the viewer and forces a consideration of artistic form and documentary practice. He lives and works in San Francisco.

Emmet Gowin

Emmet Gowin has been a professor of visual arts at the Lewis Center for the Arts since 1973. He is the recipient of a Guggenheim (1974), two NEA

Fellowships (1977, 1979), awards from the Southeastern Center for Contemporary Art (1983), and a Pew Fellowship in the Arts (1993-94). Gowin's work has appeared in retrospectives at the Philadelphia Museum of Art and other museums throughout the United States. His work is represented by Pace/MacGill Gallery in New York.

Gregory Halpern

Gregory Halpern has a BA in History and Literature from Harvard University and an MFA from California College of the Arts. In 2011 he published a book of photographs entitled *A*, with J&L Books. He teaches photography at the Rochester Institute of Technology.

Tim Hetherington

Tim Hetherington (1970-2011) was a British-American photographer and filmmaker. His work ranged from digital projections to fly-poster exhibitions to handheld-device downloads. Hetherington published two monographs, *Long Story Bit By Bit* (Umbrage Editions, 2009) about Liberia, and *Infidel* (Chris Boot, 2010) about Afghanistan. His Oscar-nominated film *Restrepo*, about the war in Afghanistan, was also released in 2010. Tragically, Hetherington was killed by mortar shells while covering the 2011 Libyan civil war.

Todd Hido

Todd Hido is a San Francisco Bay Area-based artist whose work has been featured in *Artforum*, the *New York Times Magazine*, *Eyemazing*, *Metropolis*, *The Face*, *I-D*, and *Vanity Fair*. His photographs are in the permanent collections of the Whitney Museum of Art, the Guggenheim Museum in New York, the San Francisco Museum of Modern Art, and the Los Angeles County Museum of Art, as well as in many other public and private collections. He has over a dozen published books, the latest monograph being *A Road Divided*, released in 2010.

Rob Hornstra

Rob Hornstra is a documentary photographer based in the Netherlands. He has self-published five books (*Empty Land Promised Land Forbidden*

Land, On the Other Side of the Mountains, 101 Billionaires, Roots of the Rúntur, and *Communism & Cowgirls*). He has had numerous solo exhibitions in the Netherlands and abroad and is represented by Flatland Gallery (Utrecht and Paris).

Eirik Johnson

Seattle-based photographer Eirik Johnson has exhibited in spaces, including the Museum of Contemporary Photography in Chicago, the Institute of Contemporary Art in Boston, and the Aperture Foundation in New York. He has received numerous awards, including a Massachusetts Cultural Council Grant in 2009, the Santa Fe Prize in 2005, and a William J. Fulbright Grant to Peru in 2000. His publications include *Sawdust Mountain* (Aperture, 2009) and *Borderlands* (Twin Palms Press, 2005).

Chris Jordan

Chris Jordan is an internationally acclaimed artist and cultural activist who explores the frightening waste of our mass culture. His compelling, intricately detailed photographs reveal the staggering weight of statistics, inviting the viewer to see every detail as a metaphor for the role of the individual in our hypermodern society. Jordan's work is exhibited widely in the United States and Europe and has been featured in print, online, and in film and television all over the globe. He has exhibited and spoken about his work to more than fifty audiences in North and South America, Europe, Asia, and the Middle East.

Nadav Kander

Nadav Kander is the winner of many prestigious prizes including the Lucie Awards, D&AD, Art Directors Club, and Royal Photographic Society's Terence Donovan Award. In 2009, his career had two defining moments: a commission to photograph the Obama Administration, published in the *New York Times Magazine* as "Obama's People"; and receipt of the prestigious Prix Pictet prize for his landscape work in China. Kander continues to work on portraits, landscapes, and commissions, and his work forms part of some of the major collections in the world. Recent exhibitions include: "Yangtze, The Long River," Museum of Photographic Arts, San Diego; Musee de l'Elysee, Lausanne; Flowers Galleries, London; "Selected Portraits," The

Lowry, Manchester; and "Obama's People," Herzliya Museum of Contemporary Art, Israel.

Ed Kashi

Ed Kashi is a photojournalist and educator dedicated to documenting the social and political issues that define our times. He has won numerous awards including Second Prize Contemporary Issues Singles in the 2011 World Press Photo Contest, UNICEF's Photo of the Year 2010, a Prix Pictet 2010 Commission, and honors from Pictures of the Year International, Communication Arts, and American Photography. As a member of the prestigious photo agency VII, Kashi has had his images published and exhibited worldwide, and his editorial assignments and personal projects have generated six books.

Misty Keasler

Misty Keasler's work focuses on intimate portraits of people and the spaces they occupy. Projects include orphanages in Russia, garbage and e-waste dumps in several countries, her own family, and most notably the Love Hotels of Japan, which were the subject of her first monograph, published by Chronicle Books and accompanied by a solo museum show. Her work is included in the permanent collections of the Museum of Contemporary Photography in Chicago, the Museum of Fine Arts Houston, and the Dallas Museum of Art, among others. She holds an undergraduate degree from Columbia College as well as an MFA from Bard College. She lives and works in Dallas, Texas.

Lisa Kereszi

Lisa Kereszi was raised outside of Philadelphia by an antique dealer and a junkman before studying photography at Bard and Yale. Her work is in the collections of the Whitney Museum and the Brooklyn Museum of Art, and her photos have appeared regularly in *The New Yorker*. She is represented by Yancey Richardson Gallery and her most recent book (2009) is *Fun and Games*.

Erika Larsen

Erika Larsen is an American artist born in 1976. Her dedication is to creating stories about cultures and people connected to the natural world.

Shane Lavalette

Shane Lavalette is a photographer and the founding publisher/editor of Lay Flat, an independent imprint devoted to contemporary photography. He received his BFA from Tufts University in partnership with the School of the Museum of Fine Arts, Boston. Lavalette currently lives and works in Somerville, MA.

Deana Lawson

Deana Lawson's work focuses on the psychological, personal, political, and historical experiences that are implicated through the body. Lawson is a recipient of the 2008-09 Aaron Siskind Fellowship Grant and a New York Foundation for the Arts grant in 2006. Her work has been exhibited widely, and she has held artist residencies at Light Work and Visual Studies Workshop. Deana currently lives and works in Brooklyn, New York.

Joshua Lutz

Joshua Lutz is an artist and educator living and working in Katonah, NY. His first monograph, *Meadowlands*, was published in 2008 by power-House Books. His second book, *Hesitating Beauty*, will be released in the fall of 2012 by Schilt Press. He currently teaches in the Graduate School of Bard College at ICP as well as at Pratt University.

David Maisel

Photographer David Maisel chronicles the tensions between nature and culture in his large-scaled photographs of worlds that hover between the visible and the invisible, the natural and the unnatural, the sacred and the profane. He is known for depicting realms where beauty and horror converge—from cartographic views of environmentally impacted sites to images of copper canisters holding the ashes of psychiatric patients. In *History's Shadow*, his current series, Maisel re-photographs x-rays of art objects, drawing from existing archives the spectral visions of past cultures. As always, he seeks to render the invisible.

Mary Ellen Mark

Mary Ellen Mark was born in Philadelphia. She earned a BFA at the University of Pennsylvania and an MA in communications at the Annenberg

School for Communications. Honors and awards include a Fulbright Scholarship to photograph in Turkey, a Guggenheim Fellowship, the Cornell Capa Award, and five honorary doctorates. Her work has been exhibited worldwide and has appeared in numerous publications including *LIFE*, the *New York Times Magazine*, and *The New Yorker*. She has produced sixteen books, including *Exposure* (2005), *Seen Behind the Scene* (2009), and *Prom* (2012). She lives in New York City with her husband, Martin Bell.

Laura McPhee

Laura McPhee is a photographer who has worked, most recently, in the woods of Idaho, New York City, and Kolkata, India. She earned a Bachelor of Arts from Princeton University and a Master of Fine Arts from Rhode Island School of Design. Her work, which ranges from portrait to landscape to still life, is widely exhibited nationally and internationally. She is a professor at the Massachusetts College of Art and Design, and lives in Brookline, Massachusetts.

Michael Meads

Michael Meads sometimes uses his photographs as studies for his paintings and drawings, but also as a diary documenting his world and those passing through it. After spending many years documenting his friends and family in Alabama and Louisiana (a continuing work in progress), Meads currently splits his time between New Orleans and New Mexico, where he has started a photographic record of his life in the southwest and patiently awaits the return of the mothership.

Andrew Moore

Andrew Moore is best known for his thoughtful and vibrant large-format images of Cuba, Russia, Times Square, and most recently, Detroit. Over his 30-year career, he has held nine solo shows in New York City as well as exhibitions in Moscow, Paris, San Francisco, St. Petersburg, and Amsterdam, and is included in the collections of the Metropolitan Museum of Art, the Whitney Museum of American Art, the Museum of Fine Arts Boston, and the Library of Congress. He has three monographs of his work, and in 2002, he produced a film, *How to Draw a Bunny*. He is represented by Yancey Richardson Gallery in New York and teaches in the graduate program at the School of Visual Arts.

Richard Mosse

Richard Mosse got an MFA in photography from Yale School of Art in 2008. He has exhibited at venues including Akademie der Künste (Berlin), Barbican Art Gallery (London), Dublin Contemporary, Fotofest Houston, the Kemper and Nelson-Atkins museums (Kansas City), Kunsthaus Munich, MCA Chicago, Palais de Tokyo (Paris), and Tate Modern (London). Interviews and reviews have appeared in the pages of *Aperture*, *Art in America*, *Art Review*, *Frieze*, *Modern Painters*, and *Source*. Mosse was awarded a Leonore Annenberg Fellowship (2008-10) and a Guggenheim Fellowship (2011).

Zwelethu Mthethwa

Zwelethu Mthethwa received his BFA from the Michaelis School of Fine Art, University of Cape Town in 1985. In 1989, he earned a master's degree in imaging arts while on a Fulbright Scholarship to the Rochester Institute of Technology, Rochester, New York. Mthethwa's work challenges the conventions of both Western documentary work and African commercial studio photography, marking a transition away from the visually exotic and diseased—or "Afro-pessimism," as curator Okwui Enwezor has referred to it—and employing a fresh approach marked by color and collaboration.

Laurel Nakadate

Laurel Nakadate is a photographer, a filmmaker, and a performance and video artist. She was born in Austin, Texas, and raised in Ames, Iowa. She earned an MFA from Yale University. In 2011, a ten-year survey of her work, *Only the Lonely*, opened at MoMA PS1.

Ed Panar

Ed Panar was born in 1976 in Johnstown, Pennsylvania. His first book, *Golden Palms*, was published by J&L Books in 2007. His most recent publications include *Salad Days* (Gottlund Verlag, 2011) and *Animals That Saw Me* (The Ice Plant, 2011). Ed currently lives in Pittsburgh.

Christian Patterson

Christian Patterson lives and works in Brooklyn, New York. His monographs include *Sound Affects*, published by Edition Kaune, Sudendorf in 2008, and *Redheaded Peckerwood*, published by MACK in 2011.

Andrew Phelps

Andrew Phelps is an American photographer living in Salzburg, Austria. His work reflects the multicultural lifestyle he leads, spending his time between the Alps of Europe and the deserts of Arizona. Alongside an ongoing pursuit of his own work and publications, he writes a blog about photography books called *Buffet*. He is a member of Piece Of Cake.

Sylvia Plachy

Sylvia Plachy won the Dr. Erich Salomon Prize in 2009; an Infinity award for her first book, *Unguided Tour*; and the John Simon Guggenheim Fellowship in 1977. She has been staff photographer at the *Village Voice* for thirty years and has been a contributor to the *New York Times*, *Metropolis*, *The New Yorker*, and other publications. She is in many private and museum collections and has had exhibitions all over the world. Her two recent books are *Self Portrait with Cows Going Home* and *Out of the Corner of My Eye*.

Mark Power

Mark Power (b. UK 1959) has exhibited his work in numerous solo and group exhibitions across the world and he has published five monographs: *The Shipping Forecast* (1996), *Superstructure* (2000), *The Treasury Project* (2002), *26 Different Endings* (2007), and *The Sound of Two Songs* (2010). He joined Magnum in 2002, becoming a full member in 2007. He is also professor of photography at the University of Brighton, the city in the south of England where he lives.

Peter Riesett

Peter Riesett uses a large format view camera to explore his surroundings by looking at what is acquired, collected, and often cherished. He is interested in the idea of order and disorder and of making sense of it through his compositions. Riesett's work has been exhibited nationally and internationally, and he lives and works in Brooklyn, New York.

Simon Roberts

Simon Roberts's photographs have been exhibited widely, with recent solo shows at the National Media Museum, UK; EX3 Centro per l'Arte Contemporanea, Italy; and Shanghai's Museum of Contemporary Art, China. They

are represented in major public and private collections, including the Deutsche Börse Art Collection, George Eastman House, and Wilson Centre for Photography. In recognition for his work, Roberts has received several awards. including the Vic Odden Award from the Royal Photographic Society (2007) and a grant from the John Kobal Foundation (2008). Most recently, he was commissioned as the official Election Artist by the House of Commons Works of Art Committee (2010) to produce a record of the 2010 UK general election. He has published two monographs, *Motherland* (Chris Boot, 2007) and *We English* (Chris Boot, 2009).

Joseph Rodriguez

Born and raised in Brooklyn, New York, Joseph Rodriguez continues to photograph stories both internationally and domestically, seeing his work appear in such publications as *American Photo*, the *New York Times Magazine*, *National Geographic*, *Jane*, *Cosmopolitan*, *GQ*, *Los Angeles Magazine*, *Mother Jones*, *Newsweek*, *Esquire*, *Stern*, and *Der Spiegel*. He has published several of his own books, including *Still Here*, *Flesh Life Sex in Mexico City*, *Juvenile*, and *East Side Stories: Gang Life in East L.A.* (all powerHouse Books). In addition, he has received grants from Open Society Institute, National Endowment for the Arts, the Rockefeller Foundation, Mother Jones International Fund for Documentary Photography, Alicia Patterson Fellowship, Konstnarsnamden Stipendium Swedish Arts Council, and New York State Foundation for the Arts.

Stefan Ruiz

Stefan Ruiz was born in San Francisco and studied painting and drawing at the University of California (Santa Cruz) and at the Accademia di Belle Arti (Venice, Italy). He taught art at San Quentin State Prison from 1992 to 1998 and began to work professionally as a photographer in 1994. He has worked editorially for such magazines as *Colors* (for whom he was creative director, 2003-2004), the *New York Times Magazine*, *Telegraph Magazine* (UK), and *Rolling Stone*. A monograph of his work, *People*, was published by Chris Boot Ltd. in 2006.

Matt Salacuse

Matt Salacuse is a photographer who has been living and working in New York City for the past thirteen years. His focus is editorial portraits and

documentary photography. He shoots for many magazines, including *Spin, Maxim, Newsweek, XXL,* and *New York* magazine.

Alessandra Sanguinetti

Alessandra Sanguinetti was born in New York in 1968, grew up in Buenos Aires and currently lives and tries to work in San Francisco. She has received generous grants and fancy awards which allowed her to dedicate herself to *On the Sixth Day* and *The Adventures of Guille and Belinda and the Enigmatic Meaning of their Dreams,* both published by Nazraeli Press. Her work is in the collection of good museums, and she has done editorial work for magazines and newspapers she respects most of the time.

Aaron Schuman

Aaron Schuman is a photographer, writer, editor, lecturer, and curator. He exhibits his own photographic work internationally, has curated a number of prominent photography exhibitions, and regularly contributes photography, articles, essays, and interviews to publications such as *Aperture, Foam, Photoworks, ArtReview, Modern Painters, Hotshoe International,* and the *British Journal of Photography.* Schuman is also founder and editor of the online photography journal *SeeSaw Magazine* (www.seesawmagazine.com).

Jamel Shabazz

At the age of fifteen, Jamel Shabazz picked up his first camera and started to document his friends and family. Inspired by photographers Leonard Freed and James Van Der Zee, Shabazz marveled at their documentation of the African-American community and embarked upon a 35-year journey documenting various cultures and people, both here and abroad, building a massive body of work in fashion, documentary, and fine art photography. His work is focused on the human experience, as reflected by the titles of his two dozen solo exhibitions, including "Men of Honor," "A Time Before Crack," "New York Underground," "Women Only," When Two Worlds Meet," "Back in the Day," and "Seconds of My Life," which have been shown around the U.S. and in Argentina, Canada, Italy, Germany, France, and Japan.

Alec Soth

Alec Soth's photographs have been featured in numerous solo and group exhibitions, including the 2004 Whitney and São Paulo Biennials. Soth's

first monograph, *Sleeping by the Mississippi*, was published by Steidl in 2004 to critical acclaim. Since then Soth has published *NIAGARA* (2006), *Fashion Magazine* (2007), *Dog Days, Bogotá* (2007), *The Last Days of W* (2008), and *Broken Manual* (2010). In 2008, Soth started his own publishing company, Little Brown Mushroom. Soth is represented by Sean Kelly in New York and Weinstein Gallery in Minneapolis, and is a member of Magnum Photos.

Amy Stein

Amy Stein (b. 1970) is a photographer and teacher based in New York City. Her work explores our evolving isolation from community, culture, and the environment.

Mark Steinmetz

Mark Steinmetz has published several photography books, including *South Central*, *South East*, *Greater Atlanta*, and *Summertime* (all with Nazraeli Press). He is a Guggenheim Fellow and his work is held in the collections of the Museum of Modern Art, the Metropolitan Museum of Art, the Whitney Museum of American Art, the Art Institute of Chicago, and the San Francisco Museum of Modern Art, among others. He lives in Athens, Georgia.

Joni Sternbach

Joni Sternbach uses early photographic processes to create contemporary landscapes. Her photography has taken her to some of the most desolate deserts in the American West and to some of the most prized surf beaches around the world. She is currently a faculty member at the International Center of Photography and Center for Alternative Photography in New York, teaching wet plate collodion. She is represented by Joseph Bellows in La Jolla, California, and Edward Cella in Los Angeles.

Hank Willis Thomas

Hank Willis Thomas is a photo conceptual artist working primarily with themes related to identity, history, and popular culture. He received his BFA from New York University's Tisch School of the Arts and his MFA in photography, along with an MA in visual criticism, from California College

of the Arts (CCA) in San Francisco. Thomas's monograph, *Pitch Blackness*, was published by Aperture in 2008. Recent exhibitions include the International Center of Photography's Triennial of Photography and Video, Greater New York at P.S. 1/MoMa, Contact Toronto Photography Festival, and Houston Fotofest.

Brian Ulrich

Brian Ulrich's photographs portraying contemporary consumer culture reside in major museum collections such as the Art Institute of Chicago, the Cleveland Museum of Art, the Museum of Fine Arts Houston, the Museum of Contemporary Art San Diego, the J. Paul Getty Museum, the Milwaukee Museum of Art, and the Museum of Contemporary Photography. He is a 2009 recipient of a John Simon Guggenheim Fellowship. In the fall of 2011, the Aperture Foundation and the Cleveland Museum of Art collaborated to publish his first major monograph, *Is This Place Great or What*, which was accompanied by a traveling exhibition.

Peter van Agtmael

Peter van Agtmael studied at Yale. He has photographed the wars in Iraq and Afghanistan. He is represented by Magnum Photos.

Massimo Vitali

Massimo Vitali was born in Italy. He has exhibited work internationally and his photographs of beaches, *Landscapes with Figures*, was published by Steidl.

Hiroshi Watanabe

Hiroshi Watanabe has been a fine-art photographer since 2001. He has received numerous awards, including the Photolucida Critical Mass Book Award in 2006 for *Findings* and the Photo City Sagamihara Awards in 2007 for *I See Angels Every Day*. His work is in the permanent collections of art museums such as the Philadelphia Museum of Art, Museum of Fine Arts Houston, George Eastman House, Santa Barbara Museum of Art, J. Paul Getty Museum, and San Jose Museum of Art.

Alex Webb

Alex Webb, a member of Magnum Photos since 1976, is best known for his vibrant and complex color work, especially from Latin America and the Caribbean. He has published nine books, including most recently *The Suffering of Light: Thirty Years of Photographs* and *Violet Isle: A Duet of Photographs from Cuba*. The latter, a collaboration with his wife, the photographer Rebecca Norris Webb, was also an exhibition at the Museum of Fine Arts, Boston. Webb has shown at museums worldwide including the Whitney Museum of American Art; the High Museum of Art, Atlanta; and the Museum of Contemporary Art, San Diego. His work is in the collections of the Museum of Fine Art, Houston; the Metropolitan Museum of Art, New York; and the Guggenheim Museum, New York.

Rebecca Norris Webb

Rebecca Norris Webb, for more than a decade, has been exploring the complicated relationship between people and the natural world in her books *The Glass Between Us*, *Violet Isle: A Duet of Photographs from Cuba* (with Alex Webb), and her upcoming third book, *My Dakota* (Radius Books, May 2012). Originally a poet, she's exhibited her photographic work internationally, including at the Museum of Fine Arts, Boston, and the George Eastman House. Norris Webb often interweaves text and images in her work, and is currently working on a joint project in the U.S. with Alex Webb.

ABOUT THE AUTHORS

Will Steacy

Will Steacy is an American photographer and writer. He worked as a union laborer before becoming a photographer. His photographs have been featured in numerous solo and group exhibitions, including at the New Orleans Museum of Art, the Museum of the City of New York, FotoFest Biennial, and the African American Museum (Philadelphia). His work is represented in major collections, including the Haggerty Museum of Art, the Ogden Museum of Southern Art, and the Library of Congress. His work has been featured in *The New Yorker*, *Esquire*, *Harper's*, *The Paris Review*, *Aperture*, *Time*, and *Newsweek*, and on *NPR*, *HBO* and *CNN*. He lives in New York.

Lyle Rexer

Lyle Rexer is a critic, curator, and lecturer. His most recent book is *The Edge of Vision: The Rise of Abstraction in Photography* (Aperture, whose accompanying exhibition he also curated). He has written on a wide range of topics, including contemporary art, design, architecture, and photography, for such publications as *The New York Times*, *Art in America*, *Aperture*, *Parkett*, *TATE ETC.*, *Bomb, and DAMn*. He teaches at the School of Visual Arts in New York City and lives in Brooklyn.

Acknowledgements

Tom & Faye Steacy, Michael Mazzeo, Stacey Clarkson, Charles Gandee, Deborah Barr, Myer Berlow, Andrew White, Kevin DeMaria, Kate Greenburg, the Born Family, the Spirn Family, the Messick Family, Laurance Martin, Michael Itkoff, Taj Forer, Lesley Martin, Christina Caputo, Ben Franke, Cassandra Ficacci, Davis Fowlkes, Jessica Bandy, Deb Willis, Lorie Novak, Matthew Tierney, Fuzz & John Fifield, Ashford Thompson, Chris Love, Filip Kwiatkowski, Christophe Guye, Elodia Blanco, Dan Packard, Jen Davis, Jody Schmal, Joe Varca, John Gregory Williams, Wally Mason, AMS crew, POC crew, BSD crew, Local 332, City of Philadelphia, Kate Bussard, Greg Stimac, Matt Kime, Meagan Ziegler-Haynes, Nick Kelsh, Pat Kaplan, Robin Arzon, Sarah Barr, Shoko Takaysau, Joerg Colberg, Tom Drysdale, Mark Jenkinson, Phil Perkis, Wyatt Gallery, Emily Junker, Stephen Surotchak, Josh Haunschild, Alec Quig, Adam Thorman, Alexa Dilworth, Fred & Laura Bidwell, John Bennette, Julie Soefer, Denise Wolff, Sean Corcoran, Karen Thorson, Cathy Mann, Olivia Malone, Georgina Casparis, Zoe Tsuchida, Audrey Jonckheer, Kodak, Alan Rapp, Loring Knoblauch, Madeline Yale, Fred Baldwin & Wendy Watriss.

And all of the contributors for their bravery, generosity, and—most of all—for believing in this project.